A HISTORY OF
BRIDGNORTH

A HISTORY OF
BRIDGNORTH

Clive Gwilt

AMBERLEY

First published 2009

Amberley Publishing Plc
Cirencester Road, Chalford
Stroud, Gloucestershire, GL6 8PE

www.amberley-books.com

British Library Cataloguing in Publication Data.
A catalogue record for this book is available from the British Library.

ISBN 978 1 84868 393 8

Typesetting and origination by Amberley Publishing
Printed and bound in Great Britain

Contents

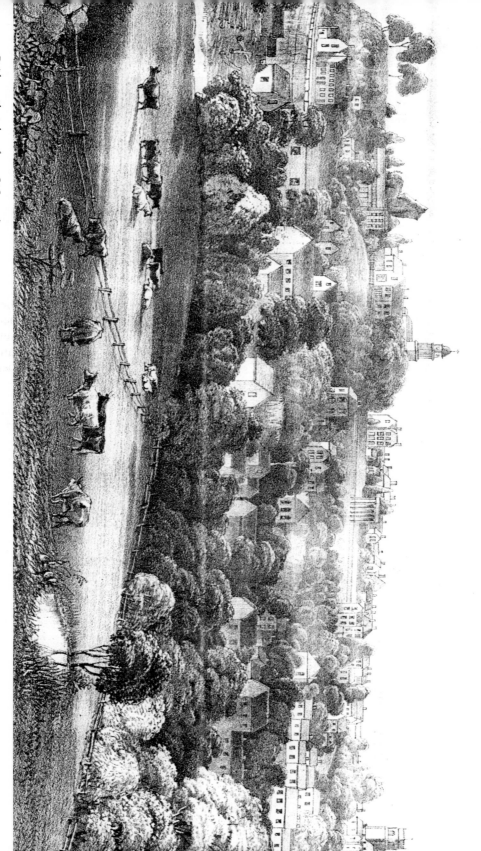

Bridgnorth, taken from St James's.

Acknowledgements

Special thanks to Bridgnorth Library, Shropshire Archives, *Bridgnorth Journal*, Chris Pitt, Keith Lincoln, the Gwilt family especially Georgina, Bridgnorth Town Council, Bridgnorth District Council, Francis Frith, Apley Estates, Margaret Amphlett, Paula Bates, Jackie Reading, Severn Valley Railway, Shropshire Star, Bridgnorth Historic and Civic Societies and other people and organisations who have allowed me to use their photographs in this historic publication.

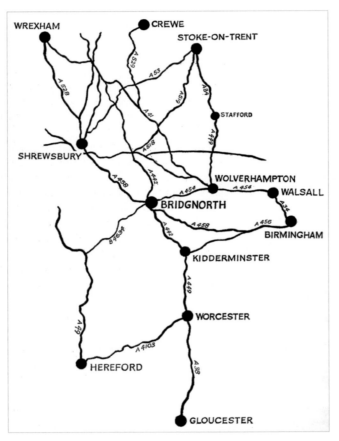

A map detailing the location of Bridgnorth, Shropshire

Bridgnorth: A Brief Synopsis

Although this quaint and historic old town has been compared by numerous travelled writers to Gibraltar, Old Jerusalem, Edinburgh and to those medieval fortress-towns on the Rhine and the Meuse, it is in reality unique. The Severn divides Bridgnorth into High Town and Low Town. Perched impressively on a bold and lofty sandstone bluff towering precipitously some 200 feet above the river, High Town commands magnificent panoramas in all directions. It is laid out on the steeply sloping right bank of the Severn and is all 'ups and downs'. Access to the different levels is afforded by stepped rock cuttings—Stoneway Steps, St Mary's Steps, Library Steps, Cannon Steps and, most conveniently, by the Cliff Railway that has the steepest and shortest incline in England. There is also the charmingly named New Road constructed in 1786, and the winding Cartway leading to the upper town.

On approaching Bridgnorth, the towers of the two parish churches, St Mary Magdalene's and St Leonard's, can be seen on the skyline.

The first mention of Bridgnorth in historical records was around 895 when the Danes set up camp at a place they called Cwatbridge, which may now have been Quatford, just downstream. In 912, Ethelfleda, King Arthur's daughter, built a castle. Roger de Montgomery had a small borough at Quatford and built a church, but in 1101 he moved it to a more defendable site at Bridgnorth.

The earliest townsfolk lived within the bailey walls of the castle but later expanded out along the High Street, surrounded by dry moats and later, in 1260, encased in high stone walls with five gates for entrances.

The first St Mary Magdalene's church was built within the castle walls in 1101 near to the site of the present one. St Leonard's was founded sometime in the twelfth century, as stones from the tower date from this time. Bridgnorth received many charters, the first one being in 1157 granted by Henry II.

In 1646, during the Civil War, Bridgnorth suffered badly as most of High Town was burned to the ground by a fire started by the Royalists defending the castle. On 31 March the castle surrendered and was blown up, leaving the Norman Keep standing at the seventeen-degree angle we see today.

The River Severn is 220 miles long and at Bridgnorth has been used for passengers and cargo as early as 1198. The barge trade flourished and many barge owners made their homes in the town. Many of the barges were built in one of the three boat

building yards on the riverside. By the seventeenth century, flat-bottomed Severn trows were used, first hauled up river by men and later by horses. Going downstream they would carry iron from Coalbrookdale, Shropshire cheese, coal and bricks from Broseley and pottery from Coalport. The last barge came down the river loaded with firebricks in 1895 but unfortunately hit the bridge and sank.

Bridgnorth produced most of the necessary items for their own use. Cloth was a major export as well as iron and bricks.

Richard Trevithick produced the first fare paying passenger locomotive in the world on the riverside at Hazeldine's Foundry in 1808 called 'Catch Me Who Can'.

Southwell's carpet factory produced a carpet in 1897 and presented it to Queen Victoria on the occasion of her Diamond Jubilee.

Prominent in the centre of Bridgnorth's main street is the town hall, a building erected in 1648–52 to replace a predecessor that was destroyed prior to the Civil War.

RAF Bridgnorth was built in 1939 as a training camp, and many thousands of recruits had their first eight weeks away from home, square bashing and firing rifles.

The Severn Valley Railway opened in 1862 as the river was in decline and was closed as part of the government's scheme to prune the country's railway in 1963.

In 1965, a group of enthusiasts formed a society and later reopened part of the railway line which expanded in 1974 as far as Bewdley, and later to Kidderminster, and still runs steam trains today.

Bridgnorth is still an important market town and surrounded by rich, fertile land, split in the middle by Britain's longest river.

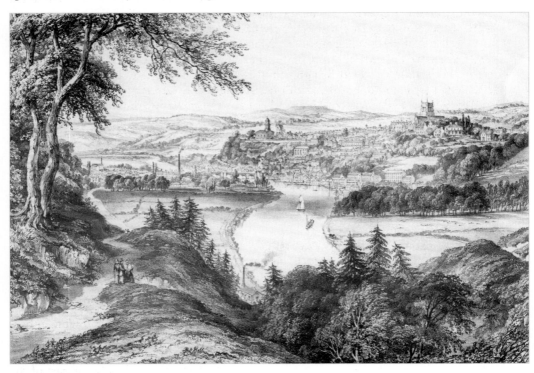

Bridgnorth from the High Road, c. 1820.

The Foundation and Castle

The first mention of Bridgnorth in historical records was about 895 when the Danes set up a camp at Cwatbridge, and in 910 a bridge at Cwatbridge is mentioned in the records of the Danish Wars. This place was probably at Quatford, a few miles down river, but may have been at Bridgnorth.

The findings of fragments of stone in St Leonard's Close prove the link with the Danes. In 912 Ethelfleda, the lady of Mercia and King Alfred's daughter, built a castle at 'Bridge', but by 1086 this castle seems to have deteriorated since it is not mentioned in William the Conqueror's Domesday Book.

The same year, Roger de Montgomery had a small Borough at Quatford in which he founded a church dedicated to St Mary Magdalene. Robert de Belleme, son of Roger, succeeded as earl in 1098, and in 1101 he transferred the church and borough to a more defendable site at Bridgnorth. It is said that Robert repaired the remains of Ethelfleda's stronghold, but the site of her stronghold is uncertain and may have been on Panpudding Hill. In 1102, Henry I besieged the castle for three months and took it from Robert de Belleme. The town then began to extend into the High Street and became a Royal Peculiar. This meant that the chapel was not subject to any bishop, and the king became the patron.

The second siege of the castle was in 1155 when Henry II is believed to have escaped death only through the self sacrifice of a knight named Sir Hugh de St Clare, who threw himself in front of an arrow aimed at the king.

In 1157, Bridgnorth received its first charter, and since then many kings and famous people have visited the town.

In 1165, Bridgnorth town wall was built in the latter part of the reign of Henry III. In the early part of his reign a stockade composed mainly of dead timber was present but by 1260 this stockade had been almost completely replaced by a strong stone wall and several gates.

In 1281, the castle was alleged to be in sad repair and Edward I deprived it of some of its military importance. In 1295, Bridgnorth began to send its own members to Parliament and in this year Edward I again visited Bridgnorth. After Edward I's conquest of Wales the importance of Bridgnorth declined.

In 1321, Edward II easily took the castle from the barons, who had burnt part of the High Town, and seized it. In 1540 Leland, the royal antiquarian, visited Bridgnorth and

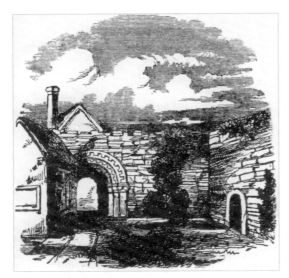

Postern Gate, 1821.

Westgate, 1910.

said 'the walls were of Great Height but the "Mighty Gate" was now stopped up, and a little postern made by force thereby, through the wall, to enter the Castle.'

In 1646 Bridgnorth was held for the king during the Civil War, but on 31 March Parliamentary forces broke through the palisade and entered St Leonard's Close. Some of the guards were killed and Colonel Billingsley, the Royalists' leader, was mortally wounded and died. The Royalists retreated back inside the castle, setting fire to some stables in Listley Street. St Leonard's church was also set alight by incendiary torches fired from the north-east tower of the castle. This caused the ammunition within the church to explode and scatter, burning timber all over the High Town. Most of the old records were housed within the church and were burnt in the fire. The fire subsequently destroyed most of the High Town, although a few half-timbered buildings from the sixteenth and seventeenth centuries survive to this day. On 26 April 1646, the castle surrendered and during the next year was practically destroyed. Unfortunately no plans or drawings exist of the castle before its demolition, even after the council offered £100 reward. Parts of the town walls still exist in Castle Street, Pound Street and Castle Grounds and a few other remnants can be seen at the bottom of some of the walls in town. The castle had five main gates: Northgate, Cow Gate, Whitbourne Gate, Westgate and Postern Gate.

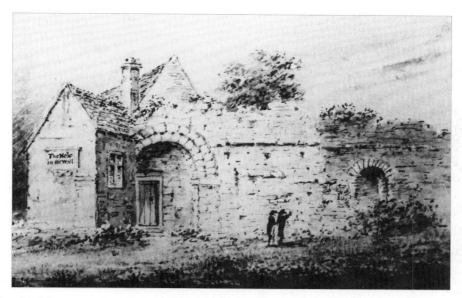

A lovely old picture showing Postern Gate and the Hole in the Wall public house built against the entrance to the castle. It was demolished at 10 a.m. on 25 June 1821 by gunpowder. In the 1550s, Leyland, the royal antiquarian, said 'the mighty gate was totally blocked and a little postern made by force'.

TO BE
Sold by Auction,
BY
DOWNES & CO.
On TUESDAY, the 17th Day of FEBRUARY, 1824,
ON THE PREMISES, LATE THE HOLE IN THE WALL,

And subject to Conditions then to be produced;

A QUANTITY OF
OLD BRICKS,
AND
TIMBER,
Belonging to the Corporation of Bridgnorth.
The Sale to commence at Three o'Clock in the Afternoon.

Bridgnorth: from the Printing Office of G. Gitton.

Poster selling the old bricks and timber from Postern Gate and small pub incorporated within its walls.

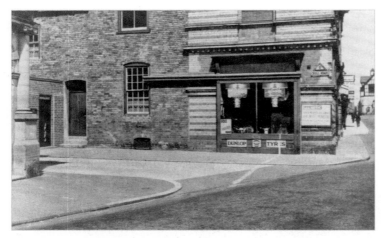

Site of Postern Gate in 1951. Demolished on 25 June 1821.

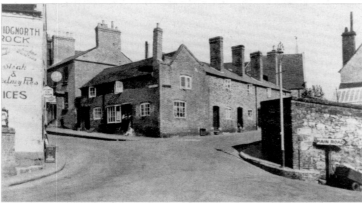

Site of Westgate or Hungry Gate. Demolished in July 1821.

Another picture of the site of Westgate on Thursday 29 August 1940, after a German Bomber dropped a big high explosive bomb described by many as a 'screamer'. It landed in the road junction of Squirrel Bank and Listley Street making a large crater and broke gas and water mains. These are the remains of Mrs Payne's shop in October 1942. It is still in a derelict condition.

The original Northgate was built in about 1260 and guarded the north entrance to the town. It was restored in 1608 and converted to a prison in 1636. Between 1646 and 1652, the large room above Northgate was used as a town hall. It has also been used as a blue coat school and today houses Bridgnorth Museum.

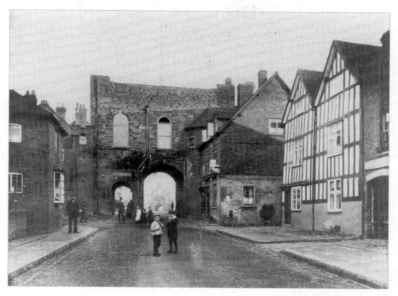

A very old picture of the Northgate (facing south), prior to the third arch being added in 1910. On the right is the Reindeer Inn. It may have been known as The Buck for a short period as it is shown as this on a map of 1835.

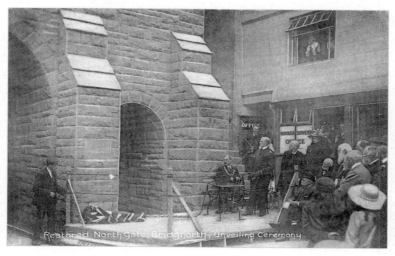

The postcard below dates from 1910 when Northgate was restored and encased in sandstone to the memory of Thomas Martin Southwell, who died on 30 September 1908 and was the founder of the Friars Carpet Works. Cost of renovations was £426 13s 3d and the opening ceremony was performed by W.H. Foster of Apley Hall.

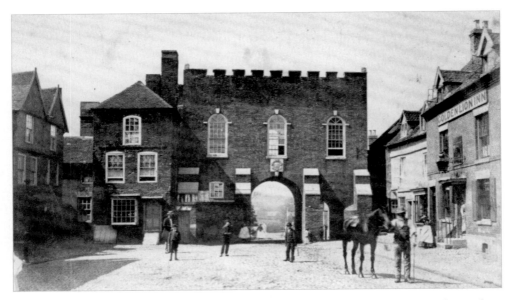

A very rare picture showing Northgate prior to restoration and also the adjoining house, later converted into a fire station. On the right is the Golden Lion, first licensed in 1790 and still serving real ale today. Note the small prison adjoining the house and the unauthorised coat of arms above the archway.

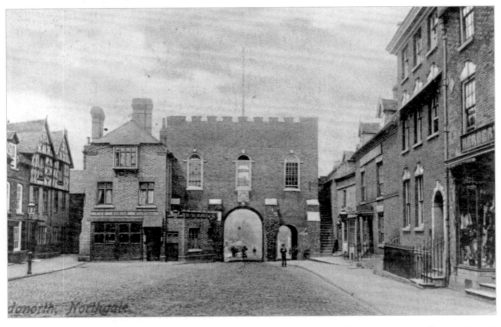

Northgate after 1878, when the building on the left was converted to the town's fire station. A hand pulled pump was used and, later, a horse drawn carriage followed by a steam fire engine in 1894. There was a large water tank to the south of the town hall and spare hoses were also stored in Low Town.

The Churches

St Mary Magdalene's Church

In 1084 a collegiate church was founded at Quatford with six canons and endowed by Roger de Montgomery and his wife Adelissa.

In 1100 Robert de Belesme, the eldest son of Roger, inherited his father's possessions. A few years later he was in conflict with the king and it became apparent to him that his position at Quatford was not very suitable for war. He moved the people to the site where Ethelfleda built the Buhr of Brycge about 912. He built Bridgnorth Castle and erected a chapel using some of the fabric of Quatford church, inside the outer bailey of the castle. This was the first church dedicated to St Mary Magdalene on this site and had attached to it the ecclesiastical foundation of the original Quatford church.

This was how the Domesday Borough of Quatford became the Borough of Brug and later Bridgnorth.

In 1330 the Burgesses of Bridgnorth petitioned parliament to 'have the use of the King's Chapel as a Parish Church'. This was presumably because of the growth of Low Town, for High Town had already had St Leonard's since about 1180.

In 1472 the parish of St Mary's was first mentioned and is the oldest surviving record of the parish.

The first St Mary Magdalene's church within the castle.

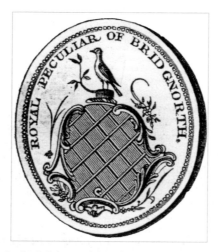

Seal of the Royal Peculiar of Bridgnorth.

The Second Church

It appears that Belesme's church was rebuilt during the reign of Edward III in a more decorative style. A north aisle was added along with a west tower; the Norman buttresses on the north side of the chancel were retained; the stone acquired for the alterations was possibly removed from a small quarry at the top of Three Ashes Bank, known as 'Maudlin's Pit'; and the Reformation Act of 1545 for dissolving chantries, colleges of priests etc., led to changes in the fitting out of the church. Stone altars were demolished and high altars replaced by a wooden communion table. The rood loft was taken down and replaced by a gallery fitted with pews, two of which faced the chancel and six faced the nave. Access to this gallery was by a staircase in front of the disused prebendary stalls. The church's status as a Royal Peculiar was in no way affected by the reformation.

In 1740 the rectory was built for the rectors of St Mary's but was not used by them until 1816. There seems little doubt about the second church becoming dilapidated about 1790.

In 1791 an Act of Parliament was passed that the church might be taken down, the Act being necessary because the chapel was still royal. The Act stipulated that no monument should be placed inside the new church and no memorial inscriptions should be placed either inside or outside its walls. The Act also prohibited any burial within the church or within a perimeter of six feet of its outer wall. It prohibited the use of the church as a polling station and the Ecclesiastical Court should be held in the vestry and not in the chancel. The court first met in the vestry on 16 February 1797. During the rebuilding St Leonard's church was used for worship. Thomas Telford was engaged in converting Shrewsbury Castle not far away and was commissioned to prepare plans for the new church. These plans were completed in 1789. The petition to pull down the old church was presented to the House of Commons in February 1792 by Hawkins Browne MP for Bridgnorth and to the House of Lords in March 1792, where Thomas Haslewood was called as a witness and estimated the costs for the stone building to be between £5,000 and £6,000.

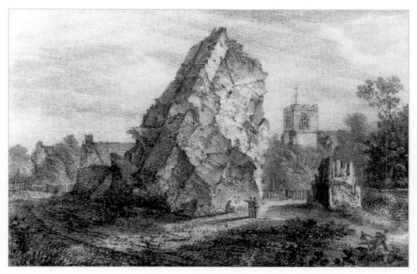

A picture from the castle grounds in 1785 showing the second church. The castle still leans at an angle of seventeen degrees, which is greater than the Leaning Tower of Pisa.

The Third and Present Church

The old second church was demolished with very little being saved. Some of the old pillars were placed at the front of St James's Priory, until recent development required them to be demolished.

One survivor is a mural tablet to the Rev. Hugh Stackhouse, now exhibited on the wall in the vestry of St Leonard's.

Work commenced on the third and present church on 17 December 1792. The stone used for the church was taken from a quarry near Eardington.

The foundation stone was laid and carried the following inscription:—

> The first stone of the New Church of St Mary Magdalene in Bridgnorth was laid by Thomas Whitmore Junior. Decr. 17th 1792 son of Thomas Whitmore Esq. MP the patron. [He was aged ten at the time.]

Telford's church was built on a north-south axis and the six bells were rehoused in a somewhat smaller belfry. Telford himself described his freestone church by saying 'the outside is a regular Tuscan elevation, the inside is as regularly Ionic, it is surmounted by a Doric tower'. The only merit he claims was 'simplicity and uniformity'.

The total cost for the demolishing, rebuilding and laying out the graveyard etc. was £6,827 11s 9d. The actual contract for rebuilding was signed for £5,500, the builder being a Messrs Rhodes and Head. The completion date was given as 29 September 1792 but work continued for some years after that as difficulty was experienced in raising all the money.

At the rear of the church is the gravestone of Charles de Preux, at one time a knight of St Louis of France.

The church, designed by Thomas Telford, as it is today. On the left is Governor's House once the home of the governor of the castle. The building on the right nearest the church is the rectory now occupied by the vicar of the church.

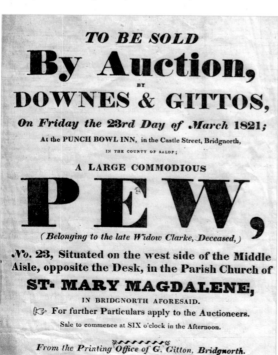

Left: *a poster advertising No. 23 pew for sale in St Mary's church. At the time some of the congregation actually owned their own pews.*

Below: *a sketch of Thomas Telford from the portrait painted by Samuel Lane for the Institute of Engineers.*

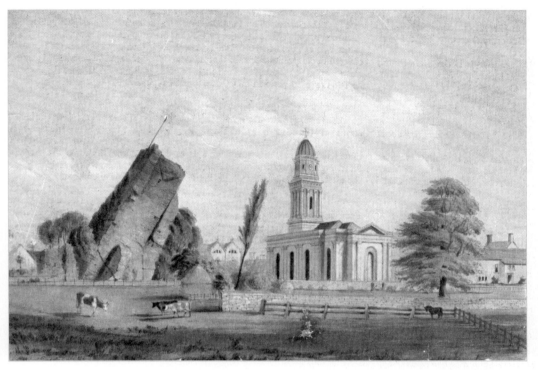

A print by Isaac Shaw in the 1840s showing the squared chancel. It was enlarged and converted into an apse in 1876 from a plan drawn up by Sir Arthur Bloomfield. It was consecrated on Tuesday 18 April 1876 followed by a public luncheon at the Crown Hotel.

St Leonard's Church

St Leonard's church was founded in the middle of the thirteenth century as the castle began to expand. It was severely damaged during the Civil War and all the town's records housed in the church for safe keeping were destroyed by fire. Within the church, three cast iron gravestones, dating between 1679 and 1707, are definite reminders of the old Shropshire iron industry. Today the church is looked after by the Churches Conservation Trust.

A major restoration took place between 1860 and 1862. It was during this restoration that two boys, according to the Blakeway papers, fell through the nave roof. The one was saved due to the heroic self sacrifice of the other. The story says two boys were playing in the upper part of St Leonard's, when some of the beams or joists parted. 'One of the boys caught hold of the beam and the other boy, slipping over his body, caught hold of his friend's legs. There they hung calling for help but no one heard them. At length the upper boy said he could hold on no longer and the lower boy said 'Do you think you could save yourself if I were to loose you?' 'Yes' said the other, 'I think I could'. 'Well then' said he, 'God bless you' and, loosing his hold, was instantly dashed to pieces. The upper boy got up on the beams and either climbed to safety or remained until someone came to his assistance.

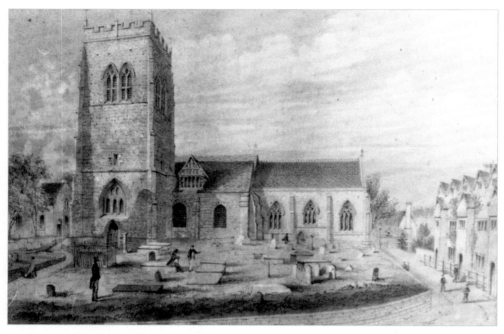

St. Leonard's church in the 1850s prior to restoration. Note the grammar school buildings on the left-hand side of the tower which are now used as Stanton, Ralph & Co. accountants' offices.

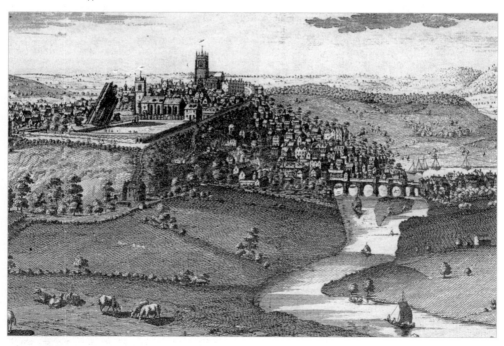

An etching by S. and N. Buck in 1732 showing both church towers prominent on the horizon.

High Town

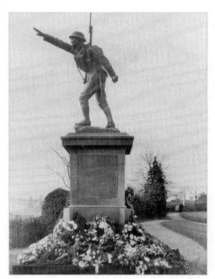

In the grounds of the castle remains is the Bridgnorth War Memorial. It was dedicated and unveiled by Private Eli Jones (late, of the Coldstream Guards) on 9 March 1922. It was dedicated by Rev. M. Linton Smith D.D, D.S.O, chaplain to HM forces during the war, and it shows a figure in bronze throwing a bomb. The work was designed by Captain Adrian Jones M.Y.O., R.B.S. The figure is seven feet six inches high and surmounts a pedestal ten feet in height. Constructed of Alveley stone, each of the four sides bear a bronze tablet in memory of those who fell during the wars.

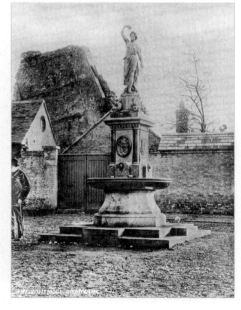

The castle grounds were given to the town by W.O. Foster in 1897 and laid out as a public pleasure and recreation ground in commemoration of Queen Victoria's Diamond Jubilee. Within the grounds is this granite drinking fountain surmounted by a bronze figure of Sabrina, the Goddess of the Severn. It was erected in 1881 outside the entrance to the castle grounds. It now stands inside the grounds and perpetuates the memory of Henry Whitmore, MP, who represented the borough in Parliament from 1852 to 1870 and died 2 May 1876. The iron entrance gates were paid for by public subscription and erected in 1957.

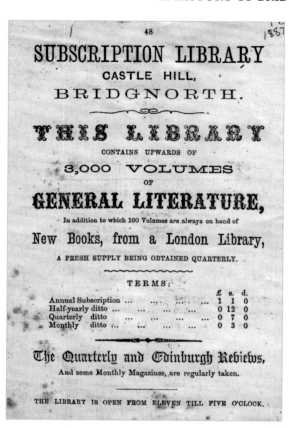

Left: *an 1882 advert for the library saying it was open 11 a.m. till 5 p.m. and contained 3,000 volumes. The library was built in 1836 on the east side of Castle Walk. The upper storey was removed in 1912 and the house is still known as the 'old library' today.*

Below: *West Castle Street in 1960 showing Bridgnorth Garage. They had moved here from the High Street and in October 1986 moved to Salop Street. The site today is now converted to houses with rear parking spaces.*

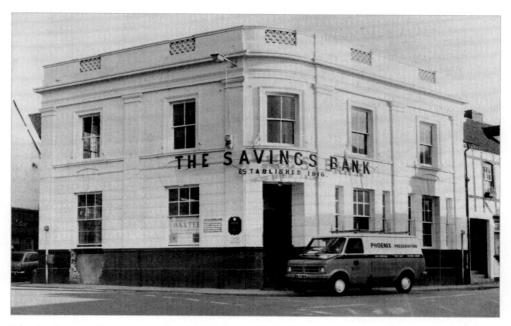

The Savings Bank, 33 East Castle Street, established in 1816, was later to become Trustee Savings Bank and is now Legends Chinese Restaurant.

Directly opposite is 1 East Castle Street; the circular building was once the Castle Restaurant and in later years Whitfields electrical shop. It has now reverted back to Castle Tea Rooms.

The Shakespeare

The Shakespeare is situated at 1 West Castle Street and was originally known as the Punch Bowl. It appears to have been first licensed in 1792, the same year that the first stone of the present St Mary's church was laid. In 1821, it was altered when Postern Gate was demolished to improve the route from New Road. In the rear buildings 'Cart' Williams had many horses stabled. A story goes one driver went out, got drunk, fell off his horse and the horse arrived without a driver. A few hours later the driver returned looking no worse for his ordeal.

J. F. WILLIAMS,
" SHAKESPEARE "
LIVERY AND BAIT STABLES,
(Opposite Post Office),
BRIDGNORTH.

Horses and Carriages of every description on hire by day, week, month or longer. Charges strictly moderate.

1892 advert stating strictly moderate charges.

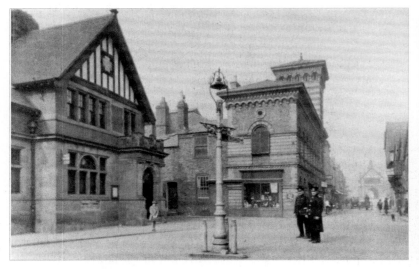

The old post office, built in 1901, is now the local mail sorting office. Behind it is a portion of the old town wall. A warehouse occupied by Thomas Deighton was demolished to make way for this building. The tall building is the Newmarket Buildings, built to house the street market. They were never used for their original purpose because the street traders refused to move and to this day still have stalls in the High Street. There is a weather vane on the top of this building depicting the date it was built. Many people will remember the Stephens Ink sign attached to the side of the Newmarket Buildings. Next to it was a chronological list of events in the town. This has now been moved to under the arches of the town hall.

This shop at 20 Listley Street is now the Shanghai Town Peking & Cantonese takeaway and opposite is Bridgnorth Library and Visitor Information Centre.

Nearly next door was the Bricklayer's Arms which was at 27 Listley Street and first licensed in 1750. It was demolished in the 1960s to make way for the expanding Comrades' Club. Since 2007 it has been the H.Q. Bar. Further down the street is the old St Leonard's School, opened on 10 May 1855 with residence for the master and mistress and now converted to eight separate dwellings called Listley Court.

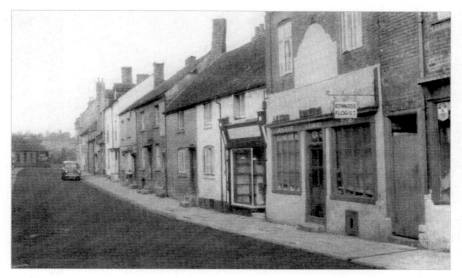

The six buildings between Edwards florist and the old car in this picture have all been demolished to make way for Listley Street North car park. The florist was No. 13 and has for many years been Frank Childs & Son hardware shop.

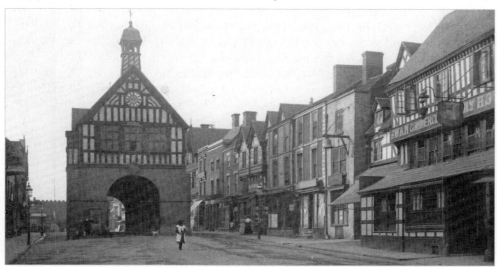

This postcard shows the town hall after 1887 when it was renovated to commemorate Queen Victoria's Jubilee. New windows were added showing all the kings who granted charters to the town from 1157 to 1830. Other windows depict an incident in Shakespeare's Henry IV, part II and Queen Victoria in her Jubilee year. On the right is the fifteenth-century Swan Family and Commercial Hotel which appears to have survived the great fire in 1646 but was partly burnt down a few years later and rebuilt. It has recently been sold and a major renovation programme is planned. The building with the bell hanging on the wall is The Bell public house. It existed as a coach house in 1836. The Shropshire Hero coach left here daily at 8 a.m. to connect with the Wonder Holyhead to London coach at Wolverhampton. After a few years the coach run seems to have been taken over by The Crown.

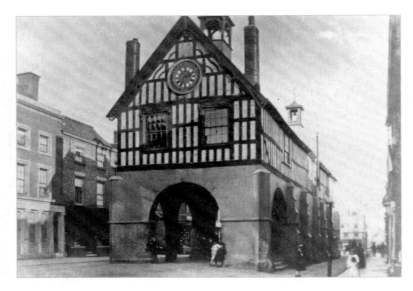

The Town Hall

In the centre of the High Street is the town hall, built between 1650 and 1652. The old town hall stood outside Northgate and was pulled down in 1945. The present building was a barn from Much Wenlock which was placed on stone arches in 1652. The clock was purchased in 1680 for only £8. A further clock was purchased at a later date for the north end of the hall. Today part of the hall is used for meetings of the town council.

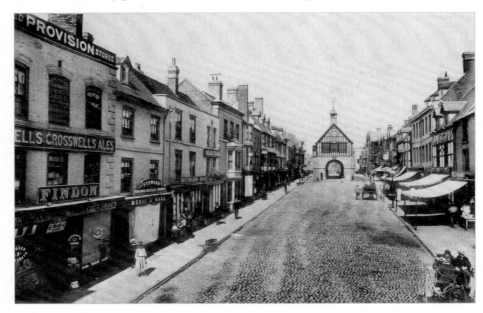

This view shows the southern end of the High Street in the early 1900s. The cobbles were removed from the street in 1904. Note the stagecoach pulled up outside the Swan Inn.

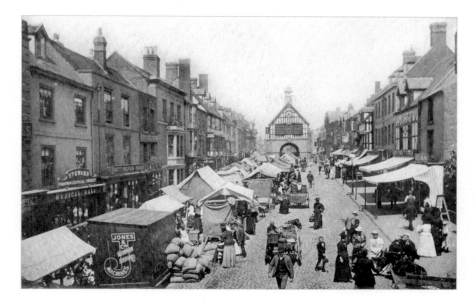

The High Cross once stood at this end of the town hall, and it was here the town watch used to assemble before going on duty each evening. It was removed in September 1645 for military reasons. The clock was lit by gas in 1867, and in about 1900 the ornamental drinking fountain on the left replaced an old pump and conduit.

During this time there were two rows of market stalls. The shops on the left could have their stall on the left of the street and the other shops on the right in the centre of the street. On the right-hand side of the street is Beaman's butchers, established in 1890 and still trading today.

The Pig & Castle at 36 High Street was one of the premier hotels in the town. It was a coaching inn with ample stabling. It was built in the typical style of an old hostelry with a long gallery at the rear. On the gallery were four carvings. The

figures can be seen today, level with the two storey bay windows on the front of the building. It is uncertain where they came from but may have been rescued from another building after the great fire of Bridgnorth in 1646. The Hibernia northern stagecoach called here at 11 a.m. and the southbound called at 3 p.m. It ran between Cheltenham and Liverpool and went to Shrewsbury via Much Wenlock. In 1856 part of the Hotel was converted to a drapery business. In 1875 Thomas Whitefoot converted the building into Castle Wine Stores and in 1925 it was sold to Tanners Wine Merchants of Shrewsbury.

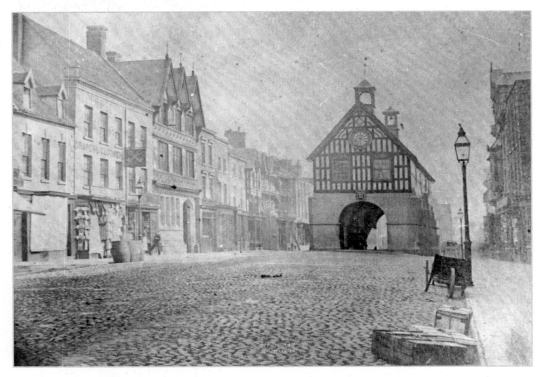

A very old photograph showing 65 High Street or 'The Great Street of Brug' as it used to be called when it was the Cross Keys Inn and Ryder & Scott Clothiers. In 1848, part of the building was converted to form the first Roman Catholic church in the town. The licensed part of the building was then at its rear, where they continued until closure in the 1930s. Also at the rear was one of three cock fighting pits in the town. Special trained cocks had their wings, tail, hackle, rump and comb clipped for battle and were fitted with two and a half inch long spurs with which to inflict the maximum damage upon their opponents. The gambling spectators crowded around the cockpit, cursing and cheering while the cocks clawed, scratched and spurred each other to death. Cock fighting was forbidden by an Act of Parliament in 1849.

No. 77 High Street was, in the 1960s, the Bridgnorth Printing Company Ltd, also known as Reynolds's. On the left was Northgate Café upstairs and Hough & Ridley hairdressers downstairs. Today the shop on the right is The Brasserie and on the left Baileys Wine Bar.

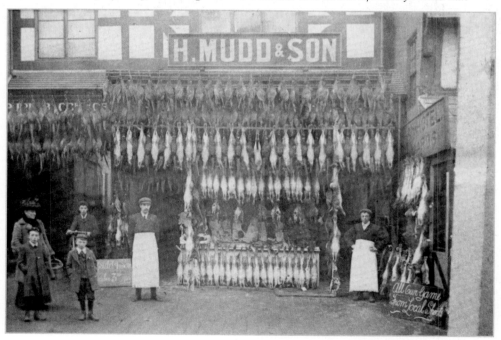

This picture was taken on 3 September 1904 and shows 53 High Street, the poultry and game shop of H. Mudd & Son. This shop was later taken over by E.J. Baker who, in 1942, sold it to S.S. Crane who added fish, fruit and vegetables.

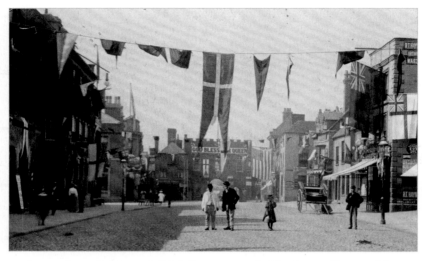

This rare picture shows Bridgnorth High Street towards Northgate. Flags and bunting are in position for Queen Victoria's Diamond Jubilee in 1897. Beyond Northgate was the recreation ground, purchased by the town council in 1885. With ten fairs each year, especially St Lukes Fair every October lasting for four days, the town was rather clogged up with merchants selling their wares. It was decided that any entertainers, merry-go-rounds or jugglers should be placed on this ground. In the 1960s, the area was converted to what is Innage Lane car park.

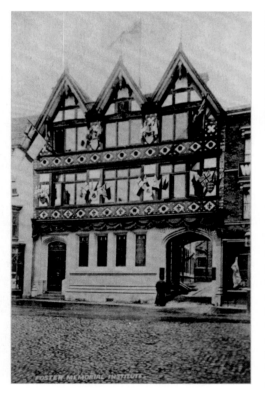

Many locals will remember William Williams's shop, which sold everything from kitchen utensils to hammers and nails. At one time there was a café and gas showroom within the shop. Today it is The Jewel of the Severn, a Wetherspoon's Public House.

This three gabled building on the left is The Foster Memorial Institute founded in 1902 at a cost of £6,000, raised partly by subscription but mainly by a contribution from Mr W.H. Foster of Apley and other members of the Foster family. The building comprises of reading rooms, a library containing 5,000 volumes, a reference library and a billiard room. There was also a private room for lady members. It was demolished to make way for Lipton's supermarket, which was later taken over by Tesco.

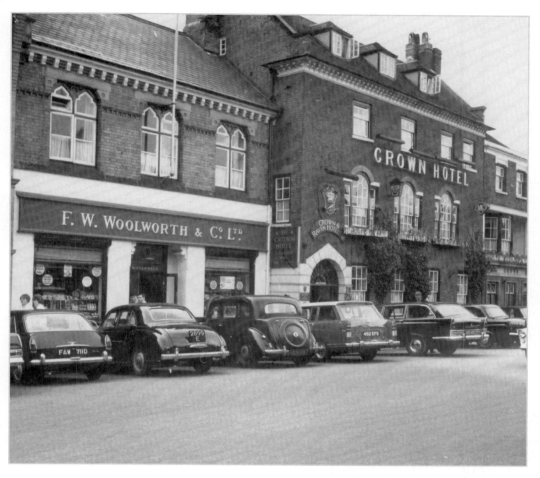

Nice old photo showing Woolworth & Co, who closed on 5 January 2009, and the Crown & Raven Hotel. Part of the Woolworth building was the old agricultural hall erected and opened on 12 January 1867 for locals to sell their produce under shelter. Bedlam's shoemaker moved to 78 High Street to allow the agricultural hall to be built at a cost of approximately £3,000. The foundation stone was laid by Captain T.C. Douglas Whitmore on 1 July 1866. George Griffiths, author of Going to Markets and Grammar Schools, *wrote 'The best company that I ever mingled with at a country market-table was that which assembled at the Crown Inn at Bridgnorth'. It has also been used as a cinema and theatre able to accommodate 600 to 700 people.*

The Pheasant was situated at 1 Whitburn Street. It moved over the road and became the Harp and Pheasant. After demolition the building we see today was built in 1879 as the Worcester City & County Bank later to become Lloyd's and more recently Lloyd's TSB. The Harp and Pheasant, after refurbishment, reopened on Tuesday 11 October 1898 as The Harp and boasted to be the only property in High Town to have thirty-two electric lights throughout the premises, powered by an engine.

Bridgnorth Grammar School

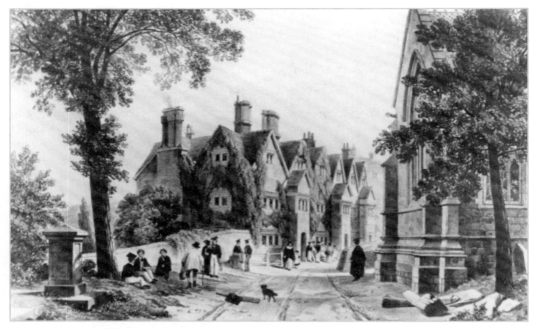

St Leonard's Close in the 1850s showing the Bridgnorth Grammar School Boarding House and Dr Rowley's Pupils. It was built in 1629 by William Whitmore to accommodate the headmaster of the school and the ministers of the church. It was later converted into lodgings for the grammar school nearby.

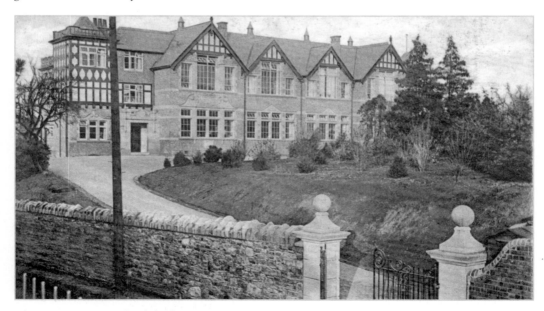

The new grammar school, built in 1908.

Bridgnorth Grammar School

Headmaster—REV. H. V. DAWES, B.A.

BOARDING HOUSE

Boarders are received at
THE SCHOOL HOUSE,
ST. LEONARD'S CLOSE

*Particulars of fees and prospectus on application to the
House Master, Mr. R. Wake, L.C.P.*

Bridgnorth Grammar School was founded in 1503 by Bridgnorth Corporation as a chantry and later, in 1595, a small building in the centre of St Leonard's Close was built to be used as the school. The headmaster and boarders stayed in the grammar school boarding house nearby. In 1785 the building was restored and by 1820 there were only ten pupils attending. In 1864, the town council declared that 'the school is not so useful and helpful to the inhabitants of the town as intended by its founder and benefactor'. In 1908 the present grammar school was built and passed to the control of the county council. In 1927, the school library was built as a memorial to boys killed in the First World War. Further additions have been made including a new science block in 1955. It changed its name to The Endowed School in 1974 when the school became comprehensive.

The Union House

The Union House or Innage House was built in 1850 in Innage Lane, at a cost of £5,229 17s 8d as a workhouse to have accommodation for 200 inmates. In 1932 part of the buildings became Innage Grange, managed by Bridgnorth Guardian's Committee who reported to the county council. In 1948 this part became an old people's residential home and in the late 1960s, after local government reorganisation, social services became responsible for the home. The front part of the building was renovated in 1994, and converted to twenty-eight small flats and renamed Andrew Evans House.

BRIDGNORTH UNION.

The Guardians meet every alternate Saturday.

Number of Parishes, 30; Population, 14,485; Acreage, 67,885; Number of Elected Guardians for Urban Parishes, 8; Number of Elected Rural District Councillors for Rural Parishes, 28; Workhouse Accommodation, 200.

For List of Parishes and Guardians, see page 14.

Officers of Board of Guardians.

Chairman :—S. RIDLEY. *Vice-Chairman :*—Rev. J. P. WRIGHT.

Visiting Committee.

Rev. S. POUNTNEY SMITH, Lieut.-Col. J. W. CUNLIFFE, Messrs. B. BUTCHER, C. D. MARE, G. LLOYD, W. WALTERS, G. C. WOLRYCHE-WHITMORE, F. H. SMITH, A. EDGE, S. WILLIAMSON and T. H. ROBINS.

Assessment Committee.

Messrs. B. BUTCHER, J CHILDE, W. CROSS, R. L. MEREDITH C. D. MARE, S. WILLIAMSON, W. WESTCOTT, W. WILSON, D. JONES, G. C. WOLRYCHE-WHITMORE, D. MORRIS, and J. LUCAS.

Finance Committee.

Lieut.-Col. J. W. CUNLIFFE, Messrs. S. T. NICHOLLS, F. H. SMITH, W. WALTERS, W. WESTCOTT, A. EDGE, G. LLOYD and J. MITCHELL.

Clerk to the Guardians and Assessment Committee :
Mr. R. F. HASLEWOOD, Solicitor.
Master and Matron at the Workhouse : Mr. and Mrs. P. C. HINES.

The Chairman and Vice-Chairman are ex-officio members of all Committees.

Medical Officers.

G. W. CECIL HODGES : District No. 2; Population, 1,255; Acreage, 12,828.

L. E. DICKSON : District No. 3; and Workhouse ; Population, 6.103 ; Acreage, 27,394.

J. C. PADWICK : District No. 4; Population, 4.321; Acreage, 10,192.

T. H. HEWITT ; District No. 5; Population, 2,806; Acreage, 18,465.

Relieving and Vaccination Officer : Mr. A. H. REYNOLDS. 14 Railway Street.

Treasurer of Union and R.D.C. : Mr. MATTHEW CHADWICK.

The rear part of Innage House, now renamed Andrew Evans House.

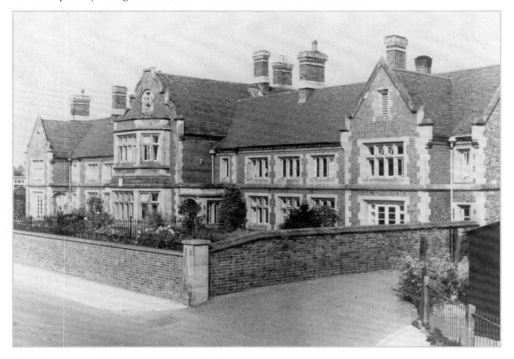

The front part of the Innage House before renovations.

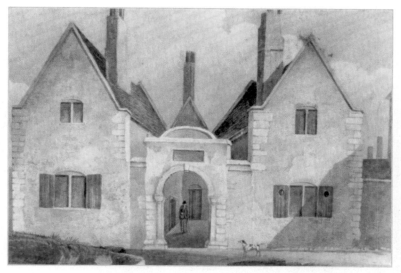

The Almshouses, in St Leonard's Close, are known as Palmer's Hospital. They were built in 1687 and endowed by the Rev. Francis Palmer who was once the rector at Sandy in Bedfordshire. Initially for ten poor widows, they have recently been modernised reducing the number of flats to eight. They were rebuilt in 1889. Next door is The College House, the offices of Bridgnorth Town Council which were built in 1709.

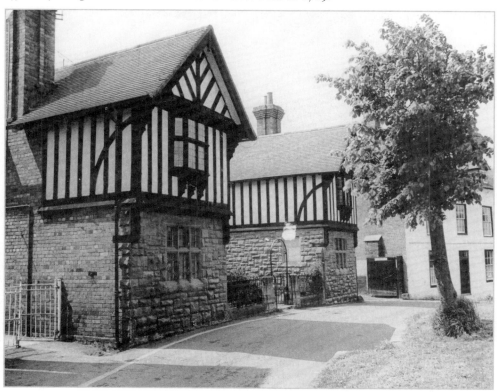

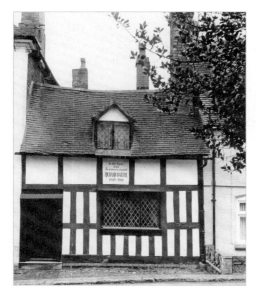

Richard Baxter

This lovely half-timbered cottage at 30 St Leonard's Close was the residence of Richard Baxter. He was the author of *The Saints Everlasting Rest* and pastorate of St Leonard's between 1640 and 1641. He then left for Kidderminster but returned in July to preach at a funeral of his former colleague, William Madstard.

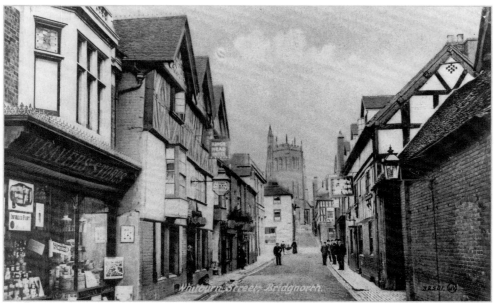

Whitburn Street showing the fifteenth-century King's Head on the left and The Raven Hotel from the same era on the right about 1912. In the foreground is the entrance to Alderson's Garage, part of which was The Old Cockpit Theatre. The cock fighting pit was converted into a theatre and opened on 11 March 1811. It has had several uses since then and now stands in the Avoncroft Museum at Bromsgrove, after being painstakingly taken down and rebuilt. Several well-known stars were drawn to the town. The most notable must have been Junius Brutus Booth, a stage rival of the great Edmund Kean. It was Junius's son who shot President Lincoln at Fords Theatre, Washington. The last performance was on 16 February 1824, and the theatre then moved to a new building at the Newmarket Buildings opened on 11 December 1824.

The Old Smithfield was once the town's cattle and sheep market. It first began about 1935 when a pasture field was used at the rear of the Kings Head. At one time there were two Smithfields, the 'old' and the 'new'. The latter coming into being on Monday 2 April 1906. The new Smithfield had two entrances, one opposite the head office and the entrance today to the supermarket. The other being from Salop Street and later known as 'Gough's entrance'. The buildings were demolished when the auctions moved further up Wenlock Road, and the site was acquired by Somerfield to build a supermarket which opened in October 1994. It was later taken over by Sainsbury's, as it remains today.

Left: *William Phillips & Co. Ltd. Mineral Water Works in Moat Street. Mineral water was bottled here from about 1880 until the 1960s. The local manager was known locally as 'Pop Jones'. It was later demolished, and 12 St Leonard's View flats and other dwellings were built.*

Below: *just outside Northgate was the town's dry moat which is now called Moat Street. The shop was managed by Mrs Capel, as a sweet shop. She can be seen standing in the doorway of 16 Moat Street and some of her sweets can be seen in the bay window to the left. It was once Frederick's Sandwich Bar and for many years it was Northgate Hairdressers and, since 2007, is now Taylor's gentlemen's hairdressers.*

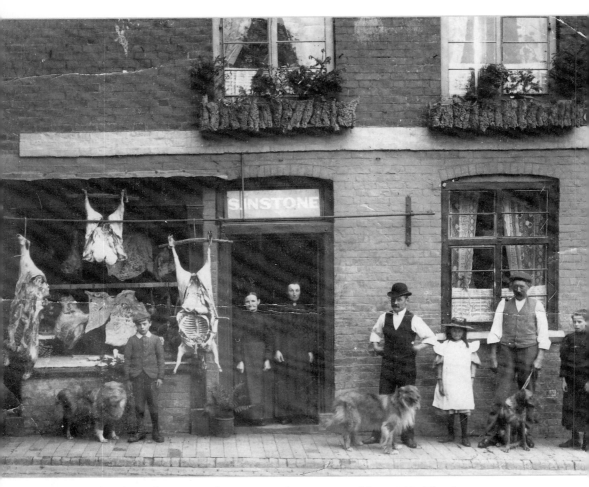

This old butchers shop opened at 30 Northgate on 19 May 1888. The front room was removed in 1909 to make the third arch of Northgate. The business then moved down to 1 St Mary's Street. Note the unusual window boxes with their bases decorated with pieces of bark.

The New Road was first contemplated on 19 December 1782 when the first general meeting of the subscribers was held. It was opened for public use four years later. Tolls were exacted from users of the road until 1852.

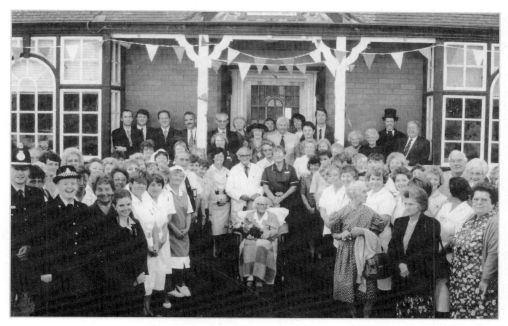

Bridgnorth Hospital first opened in Listley Street in 1835. It was later transferred to the new building which was formally opened on 17 September 1896 by Viscount Boyne. It was added to in 1909, including a new maternity block, and has recently been extended and includes a separate medical centre. This photograph shows the old front entrance during the centenary celebrations in 1996.

This building was the council depot and stores in Stanley Lane. It was demolished in 2007 to make way for new offices which opened on 11 February 2008 and have been named 'Cantern Brook Offices'.

Low Town

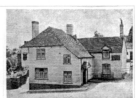

STAYING IN BRIDGNORTH?

then the obvious choice is the

SQUIRREL HOTEL

Proprietors Mr. and Mrs. Ben Buckley

Fully Licensed

HOT AND COLD ALL ROOMS

RESIDENTS' LOUNGE

Our Assembly Room is available to large parties. Seating arrangements for 25/75

LATE BREAKFASTS
LUNCHEONS · TEAS
GRILLS · DINNERS

Quotations on Request

Telephone: BRID. 2160

The Squirrel Hotel was situated opposite the old Westgate or Hungry Gate in Pound Street. In 1851 it was listed as 'The Squirrel and Commercial'. On the left-hand side of the building there were several stables. It has now been demolished and eighteen retirement flats have been built on the site.

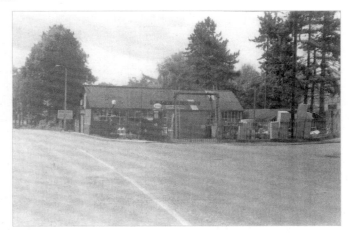

W. Powell & Son Agricultural Engineers in Hollybush Road in the 1960s. It has been Agricultural Stores for many years. It was rebuilt and enlarged in 1998 to form two separate businesses. It is one of the few places that sells red diesel for the local farmers in the town.

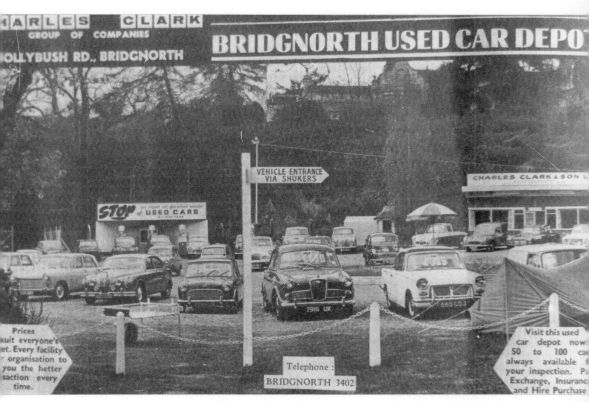

Charles Clark & Sons Ltd. used car depot in Hollybush Road in 1963. It was Enterprise Garage for many years and will be remembered for helping to save the local hospital from closure with 'Operation Enterprise'. It was taken over by Inchcape on 15 May 2001 and today consists of a large workshop and showroom.

The Low Town

The River Severn was the main means of transport for the town for raw materials and finished goods. Merchandise was carried down the Severn, including clay pipes, beer, stockings, silk, lace, guns, leather, wood, manure, butter, cheese, wool, limestone, lead, iron, clothing, grain and nails. Merchandise carried up included wine, groceries, hops, spices and brandy. Passenger traffic was recorded on the Severn as early as 1198 and King John ordered the keepers of his wine to send six tuns to Bridgnorth from Bristol. Many of the craft upon the Severn were built in one of the three dockyards. In 1757 Bridgnorth had seventy-five vessels trading on the river, and these were owned by forty-seven different bargemasters. The Severn is 220 miles long and regularly there wasn't enough water for the barges or trows to sail so the vessels would be grounded until a flush came (a rise of two to three feet) to enable them to sail. The first mention of a bridge in Low Town was in 1272 when a Benthall man accused of robbery turned to defend himself on the bridge and was killed.

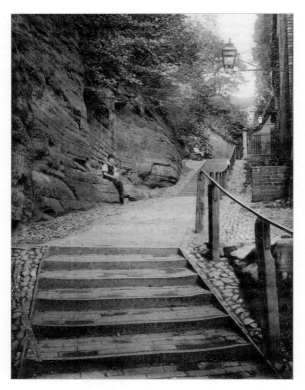

The Stoneway Steps

Stoneway steps run between High Town and Underhill Street. There are over 200 steps that were used as the main route for river cargo to High Town. Donkeys were used with 'panniers' to carry much of the merchandise up the pebbled steps. Bridgnorth's last donkey man was Richard Dukes who lived in Cartway and had to walk his donkeys through his sitting room to the stables at the rear. In 1830 John Mytton of Halston Hall near Shrewsbury rode up Stoneway Steps and around Castle Walk for a bet.

About halfway up the steps on the right is the Theatre on the Steps. The original building in 1709 was a Congregational chapel. This was demolished in 1829 and a new, larger chapel built at a cost of £1,000. In 1962 the chapel closed and resulted in a union of the Methodists, Primitive Methodists and Congregationalists who merged as the United Reformed Church and began worshipping in Cartway church. It was then that the Theatre on the Steps began fund raising and refurbishing. Today the theatre regularly hosts performances throughout the year.

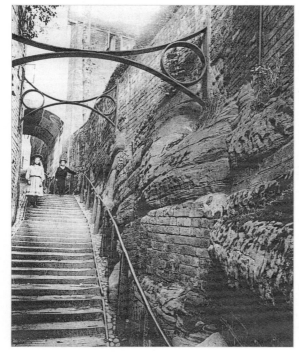

The iron buttresses, known locally as 'Pope's Spectacles', were made in 1852 by John Pope in Low Town.

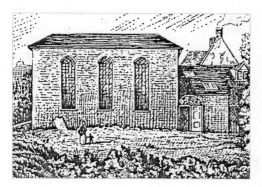

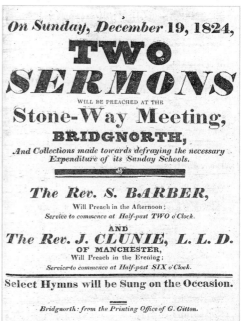

Above: *the Congregational chapel and Samuel Barbers' manse in 1840.*

Right: *a poster advertising two sermons at Stoneway chapel, 1824.*

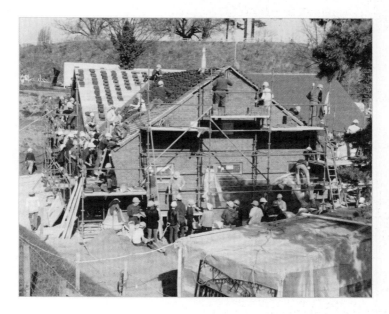

After the initial foundations and pipe-work were laid, the Kingdom Hall of Jehovah's Witnesses was built in just three days over the weekend of 17–19 April 1987. It was built by Jehovah's Witnesses from the local congregation and surrounding area, who volunteered their time. It held its first public meeting on the Sunday afternoon in the 'quick build' and continues to hold public bible meetings twice a week.

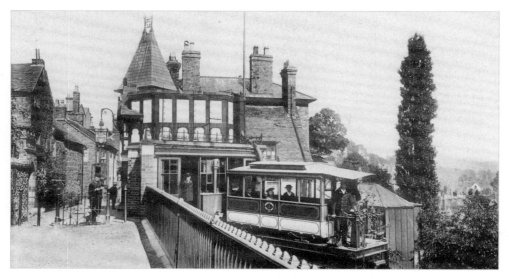

The Cliff Railway

The Cliff Railway was first proposed in 1890 to provide an easy passage between High Town and Low Town and avoid the steep banks or 200 or so steps. Construction commenced on 2 November 1891 and, after a few problems, opened on 7 July 1892. The two carriages were mounted on a framework of steel girders and each housed a 2,000 gallon water tank. This tank was filled at the top station from a 30,000 gallon water tank on top of the station roof. When full it weighed nine tons, sufficient to raise the lower carriage and the maximum of eighteen passengers. When the carriage reached the bottom, the water was emptied out and pumped up to the main storage tank, and the process repeated. The speed of 125 feet per minute was controlled by two forms of automatic brake, a speed governor and a manually operated brake controlled by a brakeman.

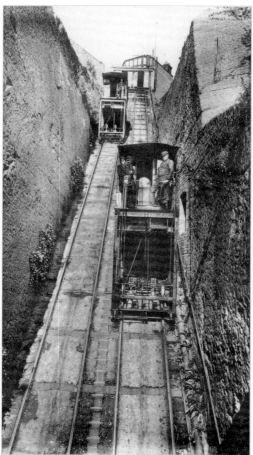

Above: *the top station with the water tank on top of the station building.*

Left: *the carriages with brakemen present.*

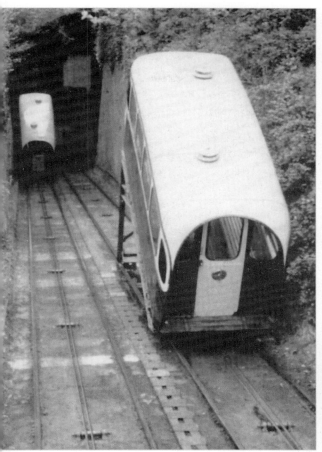

In 1955, the present day carriages were fitted with improved lighting and heating. Eleven years prior to this, the hydraulic operation was converted to electrically-worked winding with many new safety devices and the fitting of modern air brakes. The speed was increased to 250 feet per minute. In the early days during some winter periods the railway closed due to lack of customers. The railway has the unique distinction of being the only inland cliff railway, and has the steepest and shortest incline with a 1:1½ gradient and is 201 feet long.

A nice old photograph that should bring back many memories when Cartway was two-way traffic. It made a few cars struggle, especially on the bend by the fish and chip shop. The Cartway needed six or eight horses to pull up a stagecoach or carriage but was the only route for traffic to High Town before the New Road was built. Many of the houses here have outside caves used as storage. These were public or lodging houses for the bargemen, public houses or even brothels.

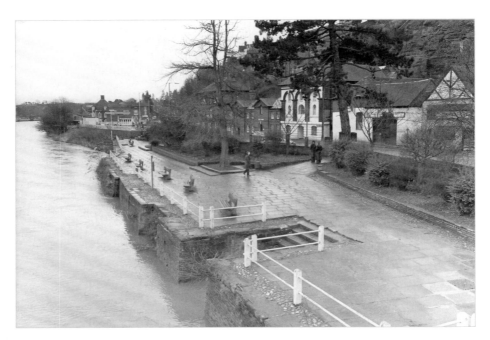

Over the road from the Cliff Railway, we now have a quayside with landing steps. The tree in the centre is a ginkgo or maidenhair tree and dates back to prehistoric times. It is only cultivated in Japan and China and is described as 'a living fossil unchanged since prehistoric times'. The postcard below in 1912 shows, on the quayside, many warehouses and buildings including the Harbour Master's House, Jones's Saddle makers' workshop, Hop Pole Inn and Quay Restaurant. There was also a 'capstaye winde', a type of hand operated winch to assist with mooring the boats.

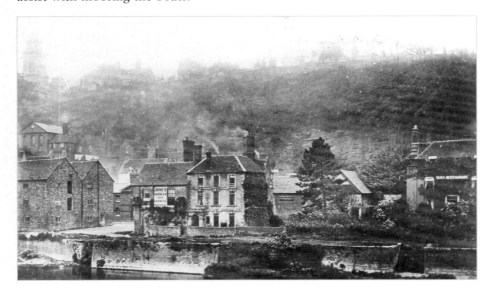

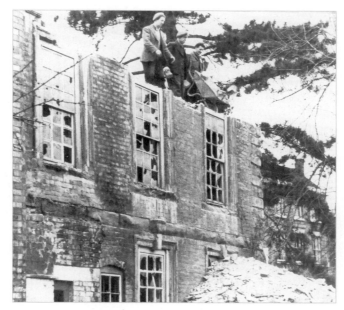

This picture, taken in May 1960 shows the demolition of the Harbour Master's House built around 1690. It was the home of the river steward who supervised work on the quay. It was demolished to improve the approaches to the bridge.

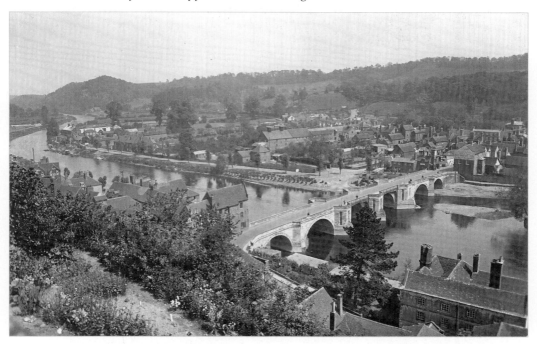

The river from Castle Walk, showing the buildings on the quayside on the right and several of the Hazeldine's Foundry buildings on the far left, some of which were bought in 1983 by Bridgnorth Rowing Club.

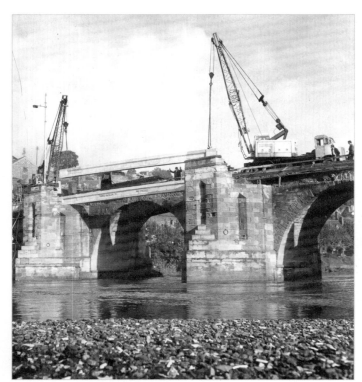

The Bridge

The bridge was widened in 1960 and the old railings replaced with the ones we see today. Note the metal rings still connected to the bridge for mooring the boats.

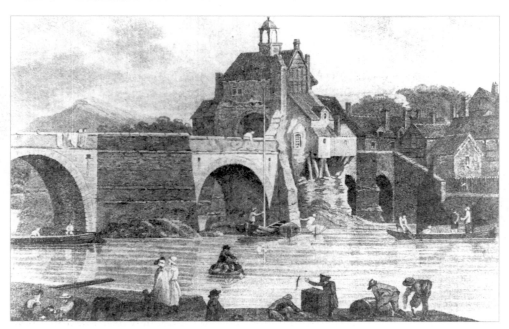

A painting from the quayside in 1797 by J. Farington showing the gatehouse, demolished in 1801.

St. Mary's School in Hospital Street was erected in 1847 at a cost of £756 to the memory of the late Thomas Whitmore. It was enlarged nine years later and recently was demolished along with Little St Mary's church hall to make way for the car park, job centre and community hall in Severn Street. Many pupils remember carrying their tables and chairs up the Grove Steps to the New School in Morfe Road on The Grove which opened on 16 May 1969.

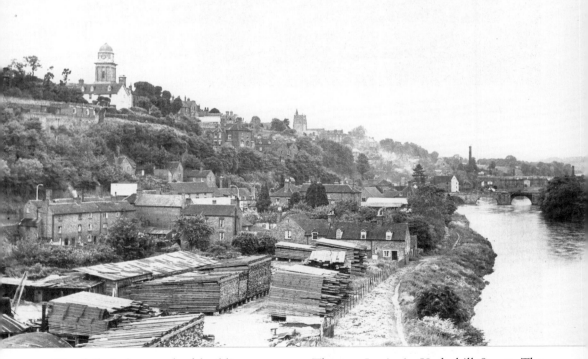

The full timber yard of building company, Thomas Lay's, in Underhill Street. The building on the right is the George and Dragon public house which was situated at 22 Underhill Street although the narrow lane to it was locally known as George & Dragon Lane. At least one 96ft ocean-going vessel was built here as it was also a boat yard. Today the site has an office block named 'Lasyard House', and a housing estate named after the nearby quay 'King's Loade'.

Notice

IS HEREBY GIVEN,

That any Person who shall deposit in the **PUBLIC STREETS** or **CAUSEWAYS**, in Bridgnorth, any

ASHES,

Rubbish, Timber,

STRAW, DUNG,

Or other Matter;

so as to obstruct the same, are liable to a Penalty of

Ten Shillings,

Under the provisions of the General Highway Acts, which provisions will be enforced in all cases which may hereafter occur.

BY ORDER OF

THE BAILIFFS.

Bridgnorth, October 2d, 1826.

GITTON, PRINTER, BRIDGNORTH.

A poster to help keep the streets clean before the age of mechanical roadsweepers.

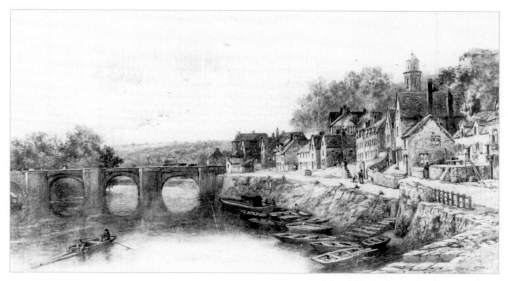

One of my favourite paintings of the bridge in 1897 by William Pitt. It shows the old towpath, constructed in 1799, that was used by men to haul the barges up river, with horses later taking over the work. The roadway called Riverside was built in 1887 on old sugar bags filled with rubble to create work for the unemployed. Note St Mary's church tower on the skyline.

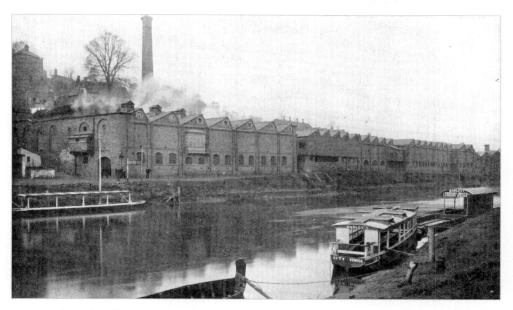

Picture of Southwell's carpet factory in 1912. It is thought that it was founded in about 1809. The earliest record of the works is a survey map of the town dated 1835. A milestone in the works history was when the workers produced a carpet for Queen Victoria's Diamond Jubilee in 1897. It contained 4,294,600 stitches and was 18 ft 2 in x 16 ft 5 in. As the factory was built on the old friary many ghost stories have emerged. The most famous is 'Old Mo' who is a friar and has been seen on many occasions.

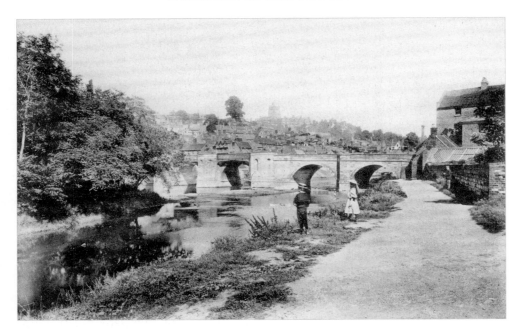

The bridge, looking north.

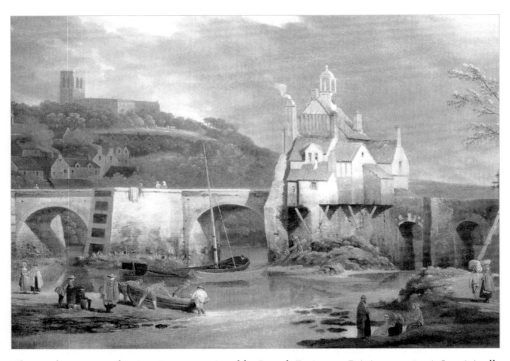

The gatehouse over the river in 1791 painted by Joseph Farington RA (1747–1821). It originally had a portcullis and for over 200 years had been used as one of the town's gaols. It has suffered much damage over the years due to severe floods, and has long since disappeared.

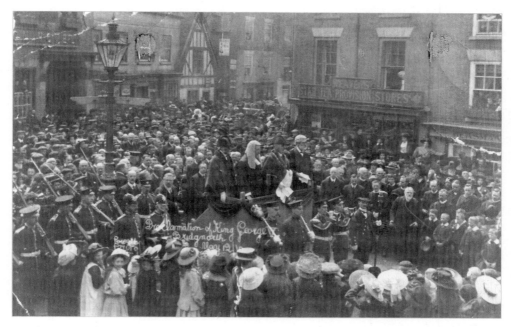

Proclamation of George V on 12 May 1910 in Mill Street. The procession assembled around a specially constructed stand from where the mayor, flanked by the Town Clerk, read out the proclamation. Two buglers sounded a fanfare before the mayor's speech.

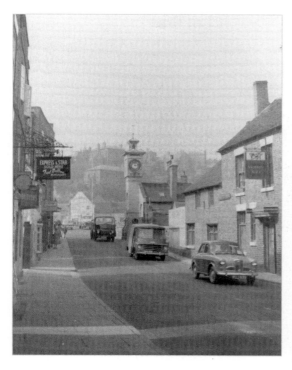

On the right is the Bull public house, which is now Bridgnorth Rugby Club's headquarters. Note the clock with the archway through it. A plaque was erected in 1949 on its brickwork and reads 'To the memory of two great engineers Richard Trevithick B. 1771 D. 1833 inventor of the high pressure steam engine and John Urpeth Rastrick B. 1780 D. 1856. Great Railway Engineer. Near this spot in Hazeldine's Foundry Rastrick built in 1808 to Trevithick's design the world's first passenger locomotive engine.

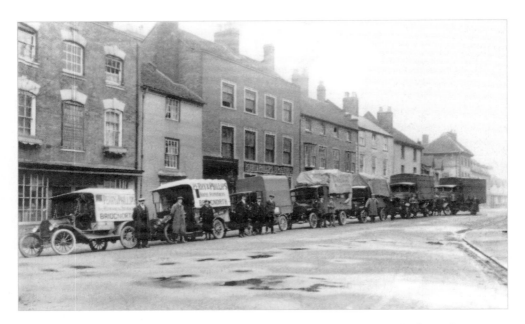

The photograph above shows Perry & Phillips at their furniture depository in Mill Street in 1914. They were lined up ready to drive to Oxford on 11 April 1921. The firm was established about 1840 and had several shops and warehouses scattered around the town. They now have the old auction rooms in Mill Street, which is the building on the far right of this photograph, and still do household removals and auctions.

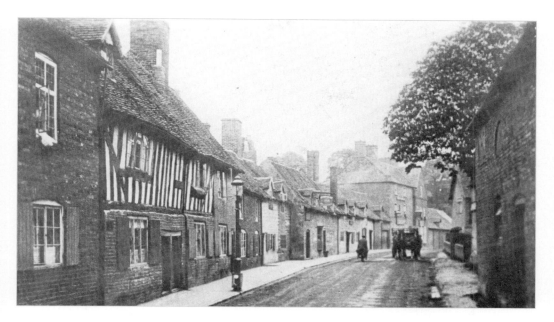

SPARRING.

The Public are respectfully informed that

TOM
BROWN,

THE BRIDGNORTH HERO,

WILL TAKE

A BENEFIT,

AT THE

Theatre, Bridgnorth,

On Saturday Evening, October 8, 1831.

From the recent Flagrant Occurrence at Doncaster, his Friends, and all admirers of true British Courage, will no doubt come forward to give him their Patronage and Support, which is respectfully solicited.

Doors open at half-past Seven, and Sparring to commence at Eight.

Admission, Boxes 3s. Pit 2s. Gallery 1s.

Tickets to be had at WM. BROWN's, *King's Head Inn, Raven-Street, Bridgnorth.*

GITTON, PRINTER.

Above: *Mill Street showing on the left two public houses the 'Crown & Anchor' and the 'Bandon Arms'. There was reference to a trial where a John Evans stole a 'mule' canary from the Crown & Anchor in 1881. He apparently put it under his hat and walked out. The Bandon Arms was called the Hand and Bottle or Bottle in Hand and had its own stabling. At the beginning of the last century it was part of the Hazeldine Foundry estate. In 1826 a Mr Thomas Brown was the landlord. He was a fifteen stone pugilist locally known as Big Tower Brown or the Bridgnorth colossus. He achieved fame when he became prize fighting champion of Shropshire in 1825. In 1828 he fought Phil Sampson at Wolverhampton Racecourse. The fight lasted forty-nine minutes and consisted of forty-two rounds. Unfortunately he lost. On the right is the entrance to Cann Hall which was demolished in the 1960s for the roundabout we see today.*

Left: *if people came on hard times, the theatre would always try to help in the form of a benefit night. Here is a poster to help our fallen hero Tom Brown in 1831.*

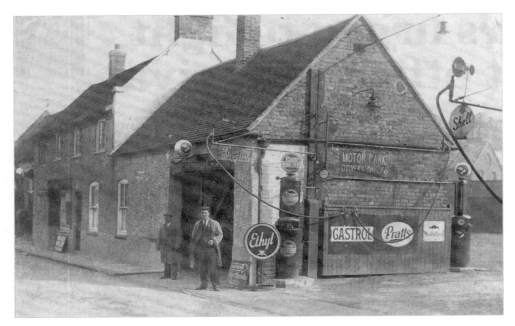

Alderson's Garage in Mill Street which was on the site of the Blue Ginger Indian restaurant. Mr Alderson is standing outside the entrance with one of his workers.

Bridgnorth College in Stourbridge Road was sold on 21 March 2007 to make way for housing. It was the Bridgnorth Campus for Shrewsbury College of Arts and Technology, but planning permission was granted for a housing development so the college buildings have all been demolished.

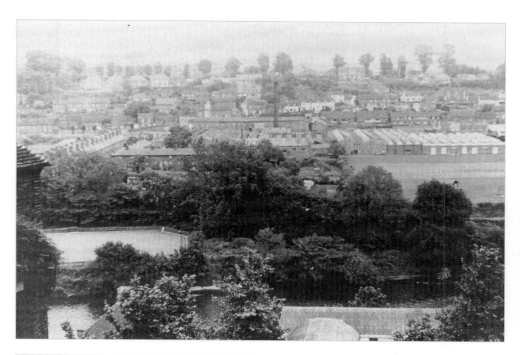

The Pale Meadow Works

The Pale Meadow Works, once a textile factory, was taken over in 1940 by the A T & E (Bridgnorth) to manufacture high quality radio receiving and radio gramophone sets, televisions, public address systems and sound recording equipment – they had been bombed out of their Birmingham home. It was later taken over by Plessey, Decca in June 1980 and then Tatung, and was one of the major employers in the town. Tatung sold in the late 1980s and moved to Telford Enterprise Zone.

The Country Set

FROM THE FACTORY IN THE COUNTRY

The Country Set is a radio telephone for use in areas where it would be too expensive or inexpedient to use normal lines. It is one of the many electronic products of A.T. & E. (Bridgnorth) Ltd. a member of the A.T.E. group, one of the largest telecommunication organisations in the world. The Company's products are exported to more than 50 countries and its engineers undertake the survey and planning of telecommunication networks in all parts of the world.

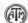 **A. T. & E. (BRIDGNORTH) LTD.**
BRIDGNORTH SHROPSHIRE

A member of the Automatic Telephone & Electric group

AUTOMATIC TELEPHONE & ELECTRIC CO. LTD. · HIVAC LTD.
A. T. & E. (WIGAN) LTD. · COMMUNICATION SYSTEMS LTD.
BRITISH TELECOMMUNICATIONS RESEARCH LTD. · OVERSEAS
DISTRIBUTING COMPANIES, FACTORIES, AGENTS AND REPRESENTATIVES IN ALL PARTS OF THE WORLD.

AT 14692

Above: *a view from Castle Walk showing the extent of the factory buildings and chimneys demolished to make way for housing.*

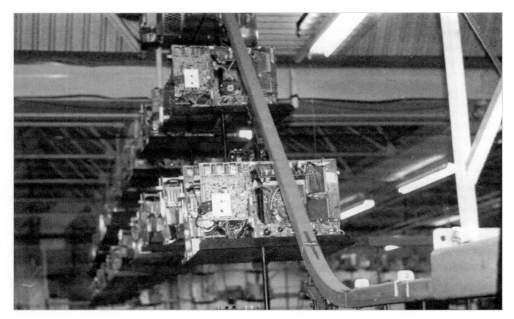

A photograph showing the production lines in 1973 when Decca made televisions at the factory.

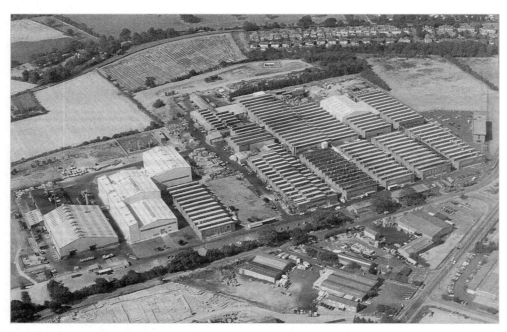

The Star Aluminium opened in 1956 for the manufacture of aluminium foil and is the town's largest employer. The company has changed names on several occasions and is now known as Novelis UK Ltd. Over the years the factory has extended and is now split into two separate companies, Novelis UK Ltd. and Bridgnorth Aluminium.

Fort Pendlestone

Fort Pendlestone Mills were on this site as early as 30 December 1225 when the sheriff of the county was ordered to have 'the Kings Mills of Brug valued'. The mills were sited at the confluence of the River Worfe and the River Severn. In 1227 the inhabitants of Brug were obliged to grind their corn at the King's Mills at Pendaston. In 1743 a complaint was laid by Francis Haslewood, who leased the Mill, that the inhabitants of the town who ought to bring their corn, grain and malt to grind refused to do so. In 1760 it was leased by the Darby Coalbrookdale Company and during 1812–13 it was occupied by French prisoners of war; pieces of furniture made by them are still in existence. It had been used by McMichaels & Co. for spinning wool until a fire in 1844 burnt down the premises. It was taken over by William Whitmore in 1845 and mostly rebuilt in a similar style to Apley Hall. It was built in a castellated pseudo-gothic style and it is uncertain how long the work took, but in 1855 it was used by Joseph Macowen for wool spinning for three years before Brinton's took it over. They continued into the 1930s when the London Cooperative Society purchased it in 1939 to use as a milk collecting centre. It handled up to 22,000 gallons of milk from 500 farmers daily. It has been a small industrial estate since and in 2008 the main buildings were converted to thirteen dwellings.

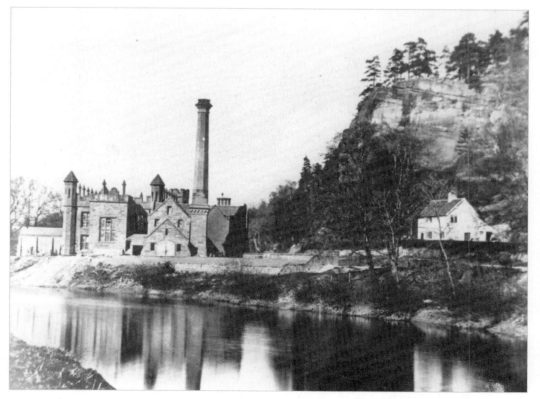

Fort Pendlestone in the early 1960s, showing its chimney which was demolished in 1969.

Bridgnorth Racecourse

Horse racing started in Bridgnorth in the 1690s, and was normally held in August or September. In 1762 they were brought forward to June, then from 1813 they were held in late July. MPs were expected to put up some trophy or other and this they did willingly in order to increase their popularity. In 1768 Lord Pigot donated a £50 plate. The races were held initially on Morfe Common. It was reputedly two miles in length and occasionally up to four miles when they crossed the Stourbridge Road and continued to the top of Spring Valley, Danesford. Many locals sold drinks without permission and the courts would fine them halfpenny, which was a small price to pay for the profits over a two or three day meeting. In 1811 the racing came to an abrupt end when the Morfe Enclosure Act was introduced. The Corporation transferred the races to the Innage the following year. The track was between the Broseley Road and Victoria Road, with the grandstand being opposite Innage House. Races ended here in 1830 but were restarted at Tasley until 1853, when they ceased due to lack of support. There was a short revival in 1869 at Tasley, but they ceased again four years later. Steeple-chasing had come to the fore by the mid-nineteenth century and a meeting called The Wheatland and Albrighton Hunt was held at Tasley in 1866. By the start of the twentieth century the name had changed to Bridgnorth and Wheatland Hunt, though by 1904 it was just plain Bridgnorth Races. The final racing took place on Saturday 20 May 1939, with 495 paying customers.

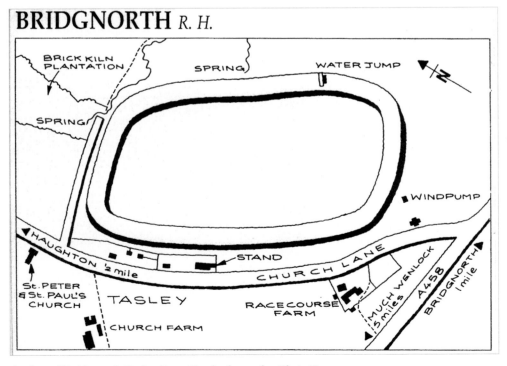

A plan of Bridgnorth Tasley Race Track, drawn by Chris Pitt.

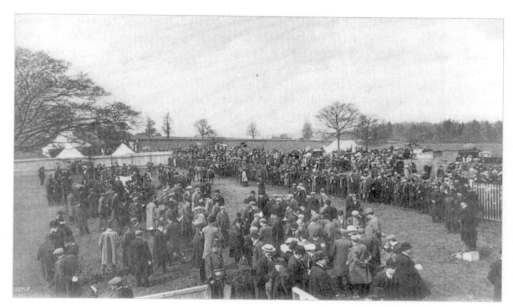

The enclosure at Bridgnorth Racecourse, Tasley 1904.

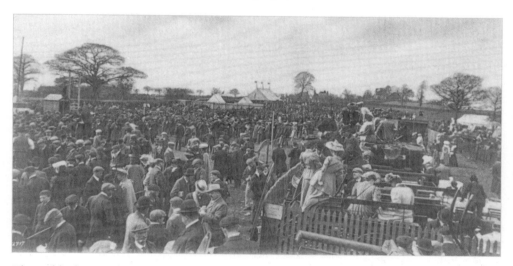

The paddock at Bridgnorth Racecourse, Tasley 1904.

Hazeldine's Foundry

There were several small brass and iron foundries around Bridgnorth, the major one being Hazeldine's Foundry in Low Town. Bridgnorth Foundry, also called Hazeldine's Foundry after John Hazeldine and his family, was situated on the east bank of the river. The sketch below shows one of the town's boat yards on the right and Hazeldine's chimney on the left in amongst the trees. It occupied about two acres stretching from Mill Street to the river. The buildings were constructed between 1791 and 1803 and consisted of a steam engine, air furnaces, smiths' shops, turning and boring mills, and the usual stores. Later buildings were constructed on the banks of the river to allow use of the river for power and for transportation of goods. In 1804, building of the first engine was begun at Hazeldine's Foundry, as well as the building of various dredgers, and repairs to the town mills and waterwheel.

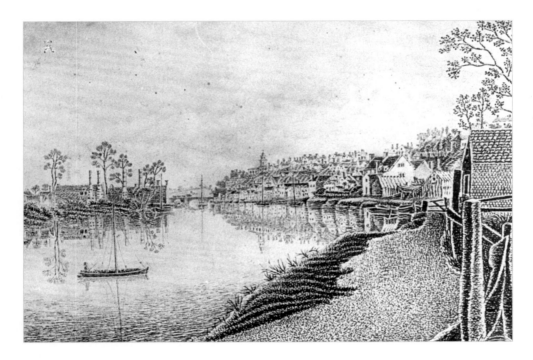

In 1808 Hazeldine's Foundry built the *Catch Me Who Can* locomotive. It weighed eight tonnes and had a similar power unit to the dredgers. It was built to Richard Trevithick's design and delivered on 12 July 1808. The locomotive was tried and tested on a circular railway at Torrington Square near Euston. He charged one shilling a ride between July and September. This was the world's first fare-paying passenger locomotive. 2008 was the bi-centenary of this locomotive and the Trevithick 200 Group have replicated a working model of the engine which is displayed annually on the Severn Park. The last Hazeldine connection with the foundry was in 1843 and it had been used for several other businesses prior to 1949 when the site became derelict.

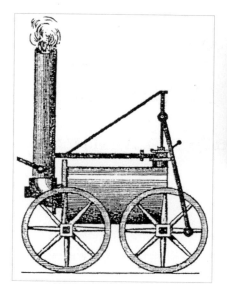

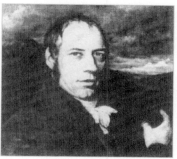

Above: *Richard Trevithick painted by Linnel in 1816, from the Mansell Collection.*

Left: Catch Me Who Can, *the world's first fare-paying passenger locomotive, built at Hazeldine's Foundry in Bridgnorth, 1808.*

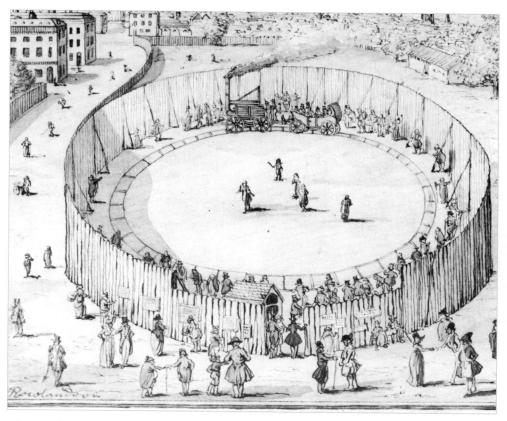

The circular track in Torrington Square, London in July 1808 where it was demonstrated to the public.

The Severn Valley Railway

On 4 April 1859 work started on the railway tunnel under Bridgnorth, ready for the laying of the railway tracks. By August 1859, after starting at both ends the tunnel had met, and in October a horse and carriage drove through the approximately 500 yards long tunnel. The Severn Valley Railway was originally opened in 1862 and covered the forty miles from Hartlebury through the tunnel under Bridgnorth to Shrewsbury. It became part of the Great Western Railway in the 1870s and was nationalised in 1948 to become part of the British Railways network. By March 1892 they were running special cattle trains on auction and fair days. Unfortunately it became uneconomical and was closed in 1963 as part of the Government's scheme to prune the country's railway system. In 1965 a group of enthusiasts formed a society to reopen the four and a half miles of line from Bridgnorth to Hampton Loade. The north track had already been lifted. The line was purchased for £25,000 by the newly formed Severn Valley Railway Company Ltd. in 1970 and was re-opened to scheduled passenger trains on 23 May that year. A further purchase of seven miles of track extended the line to Bewdley in 1974, and later in 1979 to Kidderminster. Today, the Severn Valley Railway is probably the finest example in the country of an operating, and privately owned, standard gauge railway.

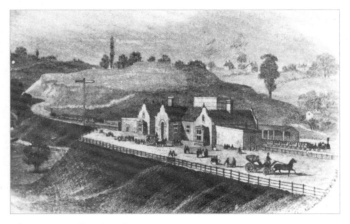

The station, shortly after opening in 1862.

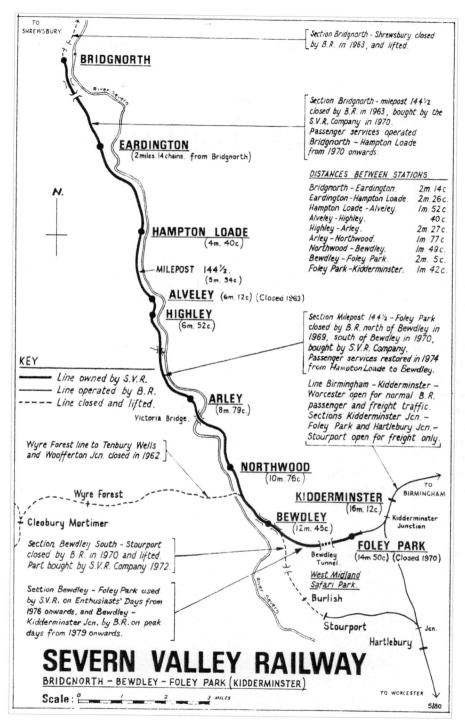

A plan of the line today.

WEST MIDLAND RAILWAY.

TIME TABLE
FOR
SEVERN VALLEY BRANCH.

FEBRUARY, 1862.

On and after SATURDAY, FEBRUARY 1st, 1862, the SEVERN VALLEY RAILWAY will be OPENED for Public Traffic, and Trains will run as follows:—

Miles		1 A.M.	2 A.M.	3 A.M.	4 P.M.	Miles		1 A.M.	2	3 P.M.	4 P.M.
	Kingstown	7 15			7 0		Bristol			7 55	3 30
							Gloucester			8 57	4 34
	Holyhead	2 0	2 0	6 50	11 40		Cheltenham		6 15	9 28	5 0
	Liverpool [Landing Stage]		7 50	10 50	3 15		London [Paddington]			6 0	1 30
	Birkenhead		8 10	11 10	3 25		Oxford			8 35	3 25
	Manchester		6 55	10 5	2 30		Malvern			11 0	5 5
	Warrington		7 50	10 50	3 15		Worcester (arr.)			11 0	5 30
	Chester		6 45	12 0	4 15		" (dep.)		8 45	11 35	5 45
		1, 2, & 4	1 & 2	1, 2, & 3	1 & 2		Wolverhampton	7 30	8 45	10 30	4 30
		Pat.					Birmingham	8 0	8 45	10 20	4 15
	Shrewsbury	6 30	10 50	3 0	5 45		Dudley	8 0	9 10	10 55	4 55
4¼	Berrington	6 42	11 1	3 10	5 57		Stourbridge	8 25	9 20	11 18	5 15
8¼	Cressage	6 54	11 12	3 20	6 9		Kidderminster	8 48	9 33	11 40	5 37
12½	Buildwas	7 6	11 25	3 30	6 21			1, 2, & 4	1, 2, & 4	1 & 2	1, 2, & 4
	Much Wenlock (arr.)		11 50	3 55	6 45			Pat.	Pat.		
	(dep. for Up Train)		11 5	3 10	6 0	11	Hartlebury (arr.)	8 55	9 40	11 55	6 25
13¼	Ironbridge	7 14	11 33	3 38	6 29		" (dep.)		9 50	12 13	6 25
15½	Coalport	7 20	11 39	3 44	6 35	13½	Stourport		10 0	12 25	6 35
18	Linley	7 31		3 55		16½	Bewdley		10 9	12 33	6 44
22¼	Bridgnorth	7 41	11 55	4 3	6 55	20	Arley		10 21	12 45	6 56
27	Hampton	7 54	12 5	4 15		22¼	Highley		10 30	12 54	7 5
29	Highley	8 3	12 13	4 24			Hampton		10 39	1 3	7 14
31¼	Arley	8 12	12 22	4 33		24¼					
35	Bewdley	8 24	12 33	4 43		29	Bridgnorth (dep.)	9 0	10 50	1 14	7 25
37½	Stourport	8 33	12 43	4 53		33½	Linley	9 10	11 0		7 35
40¼	Hartlebury (arr.)	8 45	12 53	5 5		36	Coalport	9 21	11 11	1 29	7 46
	" (dep.)	9 13	12 58	5 10		38	Ironbridge	9 27	11 17	1 35	7 52
	Kidderminster	9 25	1 10	5 30		39¼	Buildwas	9 35	11 25	1 42	8 0
	Stourbridge	9 33	1 32	5 52			Much Wenlock (arr.)	10 0	11 30	2 8	8 25
	Dudley	10 17	1 58	6 20			(dep. for Down Train)	9 15	11 5	1 20	7 40
	Birmingham	11 5	2 40	7 5		43	Cressage	9 47	11 37	1 53	8 12
	Wolverhampton	10 50	2 35	6 50		47	Berrington	9 59	11 49	2 4	8 24
51¼	Worcester (arr.)	9 30	1 35	5 40		51¼	Shrewsbury	10 10	12 0	2 15	8 35
	" (dep.)		1 45	6 25			Chester	11 45	2 5	4 5	10 20
	Malvern (arr.)	10 35	2 20	6 15			Warrington	12 45	2 53	5 10	
	Oxford (arr.)	12 5	3 50	8 45			Manchester	1 45	3 40	6 0	
	London [Paddington]	2 30	5 40	10 20			Birkenhead	12 40	2 45	4 50	10 55
	Cheltenham	10 52	4 1	7 28			Liverpool	1 0	3 5	5 10	11 10
	Gloucester	11 5	4 16	7 55			Holyhead	3 5	4 45	9 10	
	Bristol	12 20	5 35	9 40			Kingstown	7 5			

The Times shown in this Table are those before which the Trains will not depart from the various Stations; but the Company cannot guarantee any time, nor will they hold themselves responsible for delay. The Company will not be responsible for the accuracy of the hours of departure and arrival of the Trains of other Companies, as stated in this Table, as they are subject to alterations and delays over which the Company has no control.—SINGLE TICKETS are available ONLY for the Day and Train by which they are issued.

DURING THE MONTH OF FEBRUARY NO SUNDAY TRAINS WILL BE RUN.

A. C. SHERRIFF, General Manager.

PRINTED BY KNIGHT & CO. CHRONICLE OFFICE, 65, BROAD STREET, WORCESTER.

A poster announcing the opening of the railway, and an opening timetable.

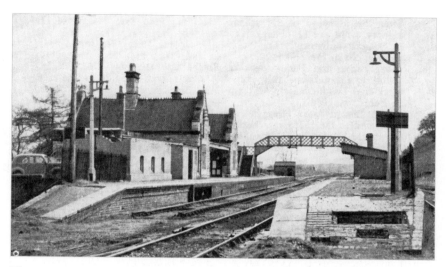

The station on 14 April 1966, prior to reopening in 1970.

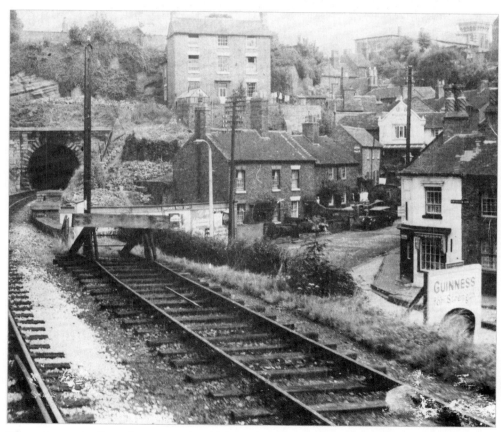

The entrance to the railway tunnel, which goes under the town and the bottom of Railway Street. Note all the advertising boards, which have long since disappeared.

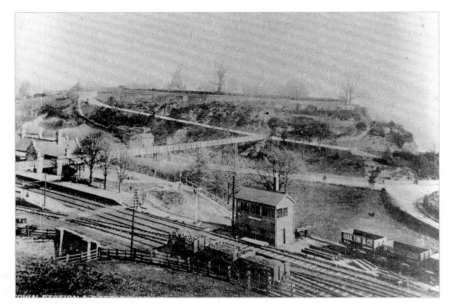

Bridgnorth Station from Panpudding Hill, showing the signal box and several waggons from Highley Mining Company. In the centre is the New Road which was cut out of solid rock in 1786.

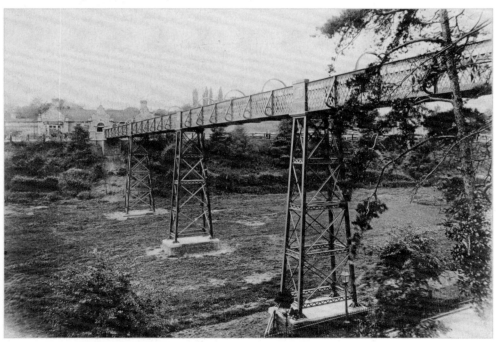

The footbridge erected in 1895, at a cost of £1,400, links the New Road with Bridgnorth Station. The footbridge seen today was erected in 1994 to replace the earlier one, dismantled due to its unsafe condition.

This photo, entitled 'End of the Line North', depicts a sad day for the town. The bridge linking Bridgnorth Station with the line running under High Town was demolished. Its loss meant trains would never run again to stations such as Ironbridge and Broseley. The tourist potential of linking Bridgnorth with what was later designated as a World Heritage Site was sadly not foreseen at the time.

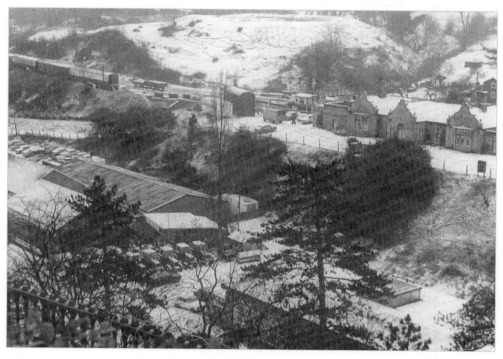

A photo of the station taken on 16 February 1979 and showing a snow-covered railway. In the foreground are Shukers tractors for sale. At the top of the photo is Panpudding Hill, used on several occasions to bombard the castle.

Halls and Houses

Bridgnorth has many large houses within its district, showing just how important the town was. Many of the gentry lived in these houses, and streets like East Castle Street were built with these clients in mind.

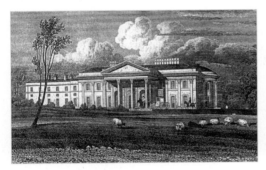

Apley Hall.

Dudmaston Hall.

APLEY HALL was built by Thomas Whitmore in 1811 to a design by Sir Humphrey Repton. The house was sold in 1867 to William Ormes Foster, who handed it down through the family. More recently it became a school, but it closed in 1987 to be converted into nineteen luxury apartments.

STANMORE HALL was built about 1870 for Mr John Pritchard who was an MP for the town, at a cost of £40,000. Today, it is a single private dwelling and the stables have been converted into ten dwellings. Previously these dwellings were the Midland Motor Museum, which had up to eighty vehicles on display but sadly closed in 1997. In the grounds was also a bird garden, that had closed a few years before.

The first STANLEY HALL was built by 1252. A farmstead in Astley Abbots, it was passed from Stephen and Juliana de Stanley to Abbot Henry of Shrewsbury. The present character of the building was conceived in 1642 by Colonel Francis Billingsley, a staunch Royalist who was killed in St Leonard's Close during the Civil War in 1646. In 1923, Mr S.J. Thompson acquired the property and in 1984 the BBC filmed a production of *Dickens' Pickwick Papers* here as it resembled 'Dingley Dell', a fictitious hall near Rochester.

Dudmaston Hall was completed in 1701 and a parapet and changed roof line added in the 1820s. It is a magnificent country mansion set in lovely gardens and woodlands known as 'The Dingle'. It had been in the same family for over 850 years until 1978 when it was passed to The National Trust by Lady Labouchere – a gift following her father's wishes. Today it has a collection of modern art, including works by Barbara Hepworth and Henry Moore, alongside sixteenth and seventeenth-century paintings, furniture and sculpture.

In 1618 Sir Francis Lacon sold the Manor of Willey to John Weld, a rich Town Clerk from London. It was left to George Forester in 1748. Willey Hall was rebuilt on the same site with a large park in 1818. The elaborate gardens were laid out and designed by W.A. Nesfield in the 1860s and additions were made in 1874 including a billiard room and extension to the kitchen. In the 1930s the Forester Family allowed the locals to skate on its pool.

Bishop Percy's House

Bishops Percy's House is situated at 52–53 Cartway and was commissioned in 1580 by a Richard Foster or Forester. He was a barge master and shipping merchant and the house became known as 'Forester's Folly'. On the ground floor there is a great hall with a dining room and great fireplace with an inscription still visible. The building today is known as 'Bishop Percy's House' after the birth of Thomas Percy there on 13 April 1729. He later, in 1782, became Bishop of Dromore in Northern Ireland and was best remembered by his *Reliques of English Poetry*. The building has been used for many trades and businesses. By 1850 it was Barkers Iron Foundry and six years later it was also a Hucksters shop. The building was used by Bridgnorth Boys Club for many years and is about to be converted into three houses, with further development at the rear on the site of the foundry.

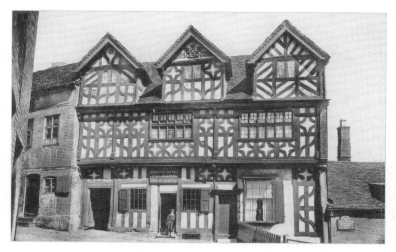

This house is deemed to be the oldest house in Bridgnorth. At this time it was being used by Charles Rushton as Bridgnorth Foundry.

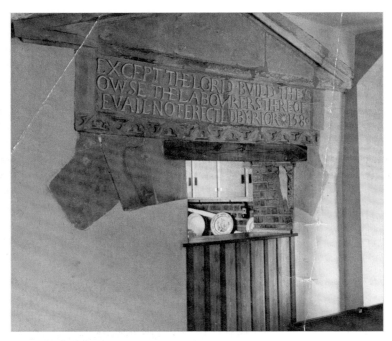

The fireplace, with inscription above.

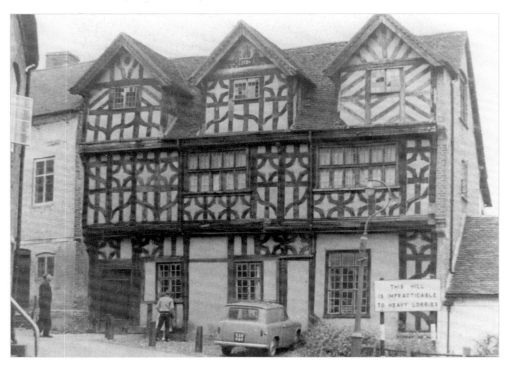

Bishop Percy's House, when cartway was two way traffic in the 1960s.

Cann Hall

Cann Hall was the residence of Mr Canne or Cann, an early MP of the town. Henry Cann was a bailiff of the town in 1324, whilst later John Cann was MP for the town from 1363 to 1365.

The first mention of the house is a lease of 1573. The house was rebuilt, or much improved, in 1594 when it had twenty-seven windows fitted. In 1623, a family named Holland lived in the house. In 1642, Prince Rupert, the nephew of Charles I, lodged here and wrote a note to the jury for the election of the next bailiffs to choose an officer well effected to the King. In 1757 the owner Thomas Whitmore was leasing Cann Hall to Nathaniel Rhodes, a seed crusher who was to build two new buildings for manufacturing. In 1835 Samuel Barber owned the property and by the 1930s it was a hotel called Cann Hall Private Hotel. Maud Cass was the last private owner from 1923 to 1956, when it was split into two dwellings. Over the next few years it was demolished to make way for the roundabout we see today. Some of the wood is still visible in Mayflower Jewellers in High Town and at Cann Cottage, Claverley.

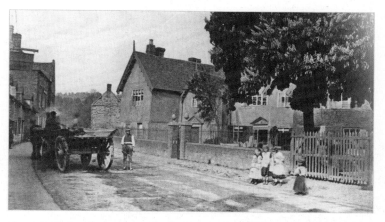

Cann Hall in about 1910. In the foreground, the gates served as the entrance to a monument works. On the left is the Crown and Anchor public house.

A copy of Prince Rupert's Letter in 1642.

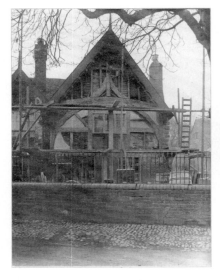

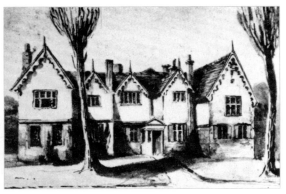

Above: *Cann Hall in the early nineteenth century.*

Left: *the demolition of Cann Hall in about 1958.*

Governor's House

Governor's House, as it is known locally, is No. 18 East Castle Street and was built in 1633 by Francis Ridley, a son of Lancelot Ridley of Astley Abbots. It is built of similar architecture to the Grammar School Boarding House in St Leonard's Close. It was occupied by the governor of the castle and the governor of the town during the Civil War period. Between 12 and 15 October 1642, Charles I stayed here with his two sons, Charles (later Charles II) then aged twelve and James (later James II) then aged nine. In June 1954 a pistol was found under the floorboards wrapped in a piece of beautiful brocade of Italian or Spanish origin, probably taken from the valance or curtains. The muzzle loading gun had the initials 'R.H.' scratched on it, undoubtedly the gun of Sir Robert Howard of Clun who was the governor of the castle in 1644, and it was probably hidden prior to the surrender of the castle. In 1953 it was converted to the offices of Apley Estates who moved from the High Street. The property is supposedly haunted by a little old lady who sits at the top of the stairs in period costume. She has confronted the residents and then disappeared. A horse has also been heard galloping along the street and stopping outside the house. The door has been heard to open as well as the sound of a booted individual running loudly up the stairs. On one occasion the residents ran out and there was nobody there and the outer door was still locked.

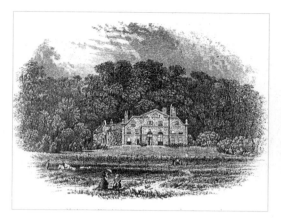

St James' Hospital

The Hospital of St James at the bottom of the Stourbridge Road was intended as a refuge for people suffering from contagious diseases, such as leprosy, and also for maimed soldiers and paralytic patients. It was founded prior to 1224 and Henry III granted the brethren one horse daily to collect dead wood for their fire. The hospital had no superior and was run by good men of the town. In the grounds there was a small chapel where the priest would say mass for the patients. It is uncertain when the hospital was closed, but it was certainly before Henry VIII's Act for the Dissolution of Monasteries and it appears that shortly afterwards, the lands and buildings passed to John Perrote. The last prior was appointed on 28 June 1543. He was Sir William Ridge. The agreement was that he should be resident in St James within three years and remain there for the rest of his life. On 4 June 1556 Roger Smith purchased the priory. The hospital was eventually demolished and two of the stone pillars were used in the construction of the present house. Several skeletons have been uncovered within the grounds, no doubt once part of the chapel cemetery. In the 1960s the property had been given permission to be demolished for re-development.

Bridgen Hall

Bridgen Hall was situated in Listley Street in about 1730 and was the home of a gentleman named William Bridgen. At the bottom of his garden he had his own vineyard, from which he made some excellent wine. Half of his vineyard was removed in 1861 when the Severn Valley Railway tunnel was built under the town. By 1820 Bridgen Hall had come into the possession of Benjamin Watts. He was twice elected bailiff of the town, 1820 and 1832. His daughter Mary Elizabeth was a talented authoress who produced many poems and works of fiction. She later married Dr William P. Phillimore of Nottingham and thus Bridgen Hall came into the Phillimore family. Sadly in the mid-1950s the hall was demolished.

Parlor's Hall

Parlor's Hall appears to have been rebuilt on the site prior to 1414 and named after the Parlor family who resided there between 1414 and 1539. Richard Parlor was a bailiff for Bridgnorth in 1417, 1426 and 1432. He was MP for the town in seven Parliaments between 1414 and 1433. Parlor's Hall was conveyed to Thomas Hoord and William Gatacre in 1539 by a William Parlor. In 1800 the building was refaced, and more recently panelling in the lounge and the Victorian room were added. Today it is a private hotel with fifteen luxury bedrooms.

St John's Hospital

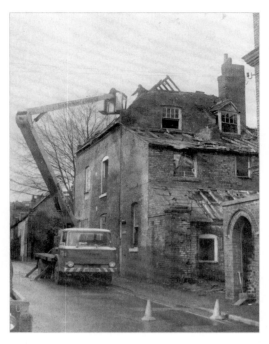

The hospital of St John or The Hospital of the Holy Trinity was founded between 1179 and 1195 in St John's Street. The exact site is uncertain. It was founded for the relief of travellers, pilgrims, the poor, the aged and the infirm in general. It was designed to entertain travellers especially pilgrims but after a few years it became a refuge for the destitute. The earliest recognition by royalty was in 1223 when Henry III directed Hugh Fitz Robert to allow the brethren of St John twelve cartloads of dry wood from the Forest of Morfe nearby. By 1638 the patronage of the hospital had passed to the Crown who then appointed the masters. It appears there have been at least two houses erected on the site, one in 1698 by Mr Lancelot Taylor which was demolished in 1759. The last 'St John's House' shown in these pictures was demolished in 1977 to make way for a supermarket and DIY store. During the work, several skeletons were uncovered, all dating between the thirteenth and sixteenth centuries, and a tile which is displayed in Bridgnorth Museum.

Diamond Hall

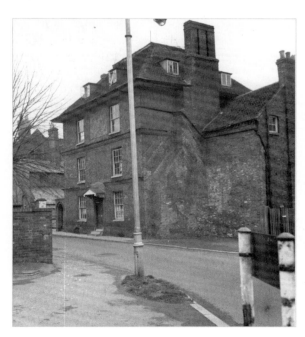

Diamond Hall as we know it was built in 1685 by Roger Pope MP. He commemorated his racing win on a horse called Diamond by building this large house. He placed a weather vane on the top showing the horse and rider which has long since disappeared. The house is now six separate apartments.

Caves

The geologist visiting Bridgnorth can readily examine the Silurian, old red sandstone, Carboniferous and Triassic rocks as well as the glacial and post-glacial deposits. The fine cliffs of red sandstone surrounding the castle hill can easily be seen as well as the Bunter Pebble-beds on Hermitage Hill. Cornes said that in the thirteenth century in Underhill Street there was a Villa Pauperum of ten or twelve houses, all roofed with natural rock. The caves were also used to brew many local beers. A quite famous one was called Eave's Cave Beer and was produced in the large cave to the south of Stoneway Steps. In 1858 John Ray, English Historian, passed through Bridgnorth and wrote 'I saw a fair street of new built homes and divers little houses cut out of rock, particularly a large wine cellar which deserves to be seen'. In 1726 the cave was measured as thirty-three feet by twenty-seven feet and a lion rampant was carved in the stone at the entrance. Eave's Cave Beer was very popular in the City of London.

South view in 1877.

Many stories have been told about a tunnel from the Hermitage caves to the castle or to the Franciscan friary, also a tale exists about buried treasure belonging to a witch who lived in the caves and flew out on her stick every night. In 1887, the caves were excavated down to solid rock but to no avail. It is thought Athelwald or Ethelwald, (second grandson of Edward the Elder and grandson of King Alfred) retired to the Hermitage caves to escape the perils of that period, and to end his days in seclusion from the outside world. On 2 February 1328 John Oxindon lived at 'Hermitage of Athewildston near Bridgnorth'. Five years later, Andrew Corbrigg and in 1335, Edward de la Mare lived here.

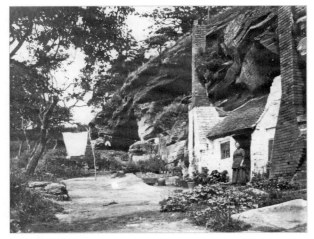

Within the caves there was a chapel measuring thirty-three feet and nearby was a freshwater well. As the caves were in Morfe Forest, one of the caves was converted to a custodians' cottage to help prevent poaching. The last cave dweller, Mr Cyril Taylor, lived in this cottage until 1928 when he moved to live at the bottom of the Hermitage Hill. Today the caves are somewhat weathered and smaller than previously.

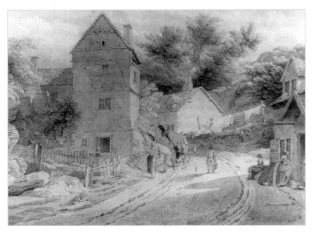

This picture, entitled 'Railway Street Bridgnorth', was found in an antique shop many years ago by an occupier of Vine Cottage.

Lavington's Hole, as it is known locally, was a man-made cave eighty-seven feet in length, cut into the rock in Underhill Street by engineer Colonel Lavington, a Parliamentary soldier. His idea was to place a mine at the end of the tunnel and blow up St Mary's church, where all the defenders had stored their gunpowder, and get the castle to surrender. His plan seemed to have worked and the cave was never blown up.

Near the Hermitage caves is a large outcrop of sandstone locally known as 'The Queen's Parlour'. A queen has never been found to be associated with the rocky headland. It is thought the rock has a stone on the top and was, in ancient times, possibly the centre of pagan religious rituals. It would have been in view of the town's gibbet near Lodge Farm Estate, where people were hanged. The few known facts about the rock only add to its mystery.

The River Severn

The River Severn is 220 miles in length and is Britain's longest river. It starts on the slopes of Plynlimon in Wales, flows into the Bristol Channel and, eventually, the Atlantic Ocean. It has the second highest tidal range in the world, which is the natural phenomenon of waves sweeping upstream, known as the Severn Bore. Bridgnorth's first barge or trow recorded was in 1205, and there was definitely a bridge at Bridgnorth in 1272. Many of the vessels were actually built in one of the three dockyards along the riverside.

Bridgnorth received its first vessel loaded with coal in 1570. In 1763 Bridgnorth was a place of 'great trade by land and water'. Merchandise was brought to the town by waggons and loaded onto barges. Tolls were paid as they crossed the bridge at the gatehouse. The bridge suffered much damage due to flooding and always needed repairs. In 1812 it was ordered that the gatekeeper was to stop any team of horses trying to avoid tolls. A farmer would attempt to evade a large toll of 8d on a four horse drawn wagon by sending one horse through separately saving 3d. Records show that three great fish (one really a mammal) have travelled up the Severn past Bridgnorth. A whale came up in the flood of 1673. A dolphin forty inches long travelled up during the 1748 flood and in 1802 an eight foot six inch sturgeon weighing 192 lbs was found. Shrewsbury weir proved the obstacle to all these monsters. In 1814 the river actually froze over for twelve weeks.

Adverts for both Darley's and Corfield's boats in 1890.

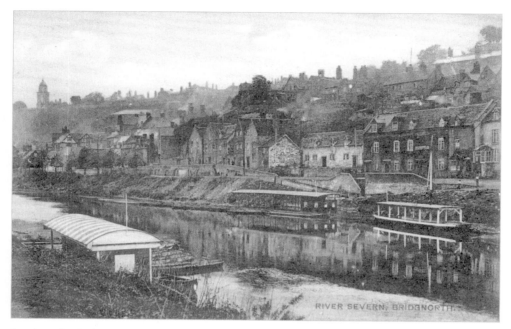

Looking back down river towards the bridge and showing Riverside. On the left is Darley's landing stage and boats, they also had a riverside café nearby for many years. On the right are Corfield's boats, the sign for their office and home can be seen on the middle house.

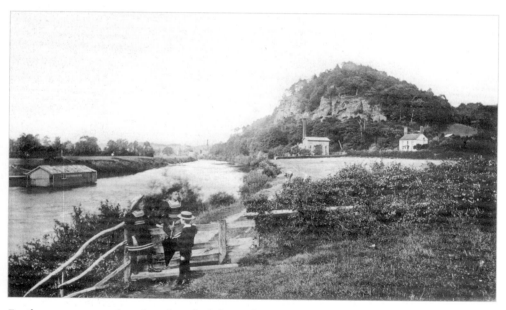

Further upstream and anchored to the left are the swimming baths, constructed in 1878. These were used by locals to swim safely in the river. On several occasions the pontoons filled with water which caused it to sink. In later years it was looked after by Bridgnorth Rowing Club. To the right is the pumping station built in 1861 to draw water from a well sunk near the river.

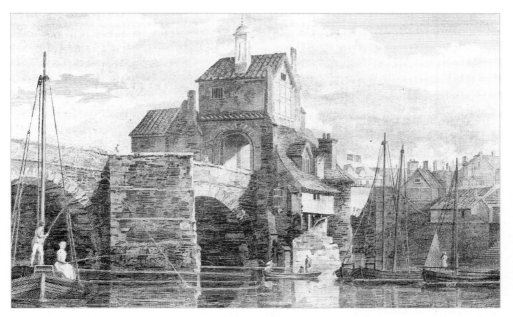

A beautiful etching of the Bridge by J.M.W. Turner, dated 1 August 1795.

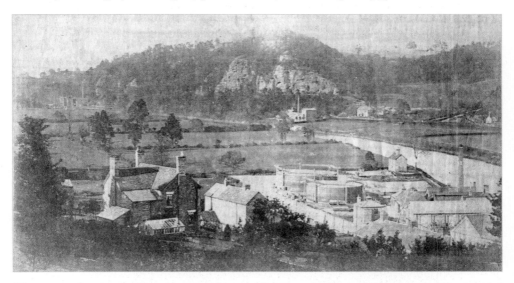

The gas works were built on the site of one of Bridgnorth's boat building yards. They needed to be near the river for easy access to the coal supplies brought by barge. They were first established by December 1834 and later, in 1881, they were taken over by the Corporation and nationalised in May 1949. In 1869 the gas lights in the town were extinguished for three days due to the river flooding. The small building near the river was the old toll house. The large outcrop in the centre is the High Rock. On the top of this rock used to be a stone known as 'Taylor's Stone', named after the sad catastrophe of a certain local tailor. The tailor used the stone as his shopboard, and sat thereon to work. He accidentally dropped his thimble and in endeavouring to catch it fell to the road below and broke his neck.

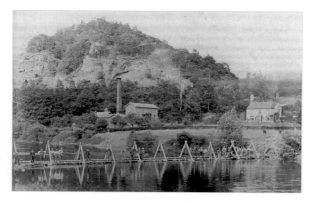

Men involved with the construction of a new water pipe across the river to the pumping station.

The cemetery was opened on 25 July 1855 and is situated below the Hermitage Hill. It has been chosen for the picturesque beauty of the secluded spot. The total cost was £2455 and contains two mortuary chapels and a house for the keeper. The first person to be buried there was Joshua Sing on 4 September. He died aged fifty-nine and was Bridgnorth's first mayor in 1836. The cemetery won the Cemetery of the Year Award in 2008 after being runner-up on several occasions.

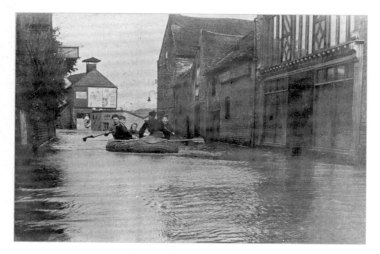

Underhill Street in 1947.

Bridgnorth Friary

The Bridgnorth Friary was founded between 1224, when the first Franciscan friars landed in Dover, and 1244, when Henry III ordered the payment of 40s towards the fabric of their church. The friars were *praedicatores* (preachers), unable to hold any personal wealth, living in the poorest parts of towns. Their motto was *Laborare Est Orare* meaning 'toil is prayer'. In 1272 they were in trouble for casting rubbish into the river to reclaim land. Many kings granted timber to the Grey Friars for rebuilding and to be used for their fires. It appears they may have introduced the conduits and water supply to parts of the town about 1303. The friars maintained a service in the St Sythe's chapel on Bridgnorth Bridge for many years. In August 1538 Richard Ingworth, King Henry's Commissioner for Visitation and Suppression of Friaries, visited the friary and mentioned 'He had taken into the Kings hand the Grey Friars of Bridgnorth, which is the poorest house he has seen and not worth 10s a year, and all the houses are falling down'. All the chattels were sold and there is very scant information until 1663 when it was the property of the Grosvenor family. During renovations to Southwell's carpet works several skeletons were uncovered. Some were found buried in graves cut out of sandstone and one contained a 'coffin chalice' and is stored in St Leonard's church. Thanks to the local preservation action group, some remains were preserved, as we see today. In the early nineteenth century an inn opened at 52 Friars Street called The Old Friar. It has now closed and been converted into three dwellings.

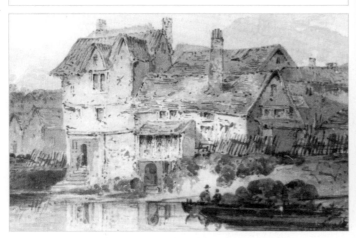

Clockwise from bottom-left: *a sketch of Bridgnorth Friary, an old advert for the Friars Inn, and a sketch of a Grey Friar, which were so-called because of their grey robes.*

The Royal Air Force

RAF Bridgnorth

RAF Bridgnorth came into existence on 6 November 1939, when many thousands of recruits had their first eight weeks away from home. It was situated at Stanmore some three miles outside the town but since there was already an Air Force Unit at Stanmore Middlesex, the station was named Royal Air Force, Bridgnorth. It was initially called No. 4 Recruit Centre and used for training recruits or 'sprogs' as they were known. Many would arrive on the Severn Valley Railway and take a Bedford bus to the camp. The eight weeks consisted of square bashing, fire arms drill, physical training, combat training and lectures. Many will remember the Gas Chamber which is now Helga's Café. Recruits would sit in the chamber with their mask on and before they were allowed out would have to remove it and inhale some of the gas. During their off duty moments the sprogs would visit the town and stop for refreshments at The Sabrina Café (now Eurasia Tandoori Restaurant), The Copper Kettle (now residential flats) or Bees Café (now Bet 365 betting shop). Time off in

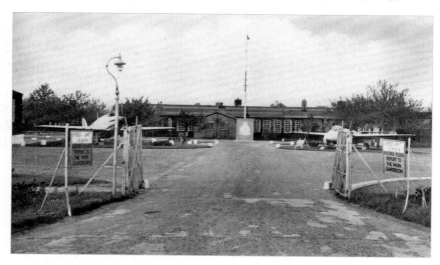

A recruit's first glimpse of the RAF camp. Note the gate guardian planes as you enter.

the evening meant a trip to The Palace Ballroom (was Woolworth's and now The Factory Shop), The Rose Marie Dance Hall (now Jewson's the builders) or The Nautical William (now the White Lodge Nursing Home). On 12 April 1950 civil honours were confirmed on RAF Bridgnorth when they were granted the right to enter the town on all ceremonial occasions and march through the streets with bayonets fixed, drums beating and colours flying. The camp closed in 1963 and was put up for sale. This was the end of an era.

 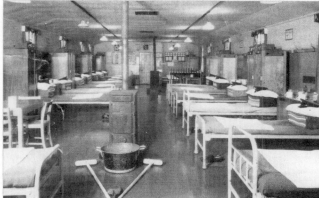

Left: *the crest of RAF Bridgnorth. The Latin inscription reads 'This is the gate, the walls are the men'.* Right: *inside one of the billets.*

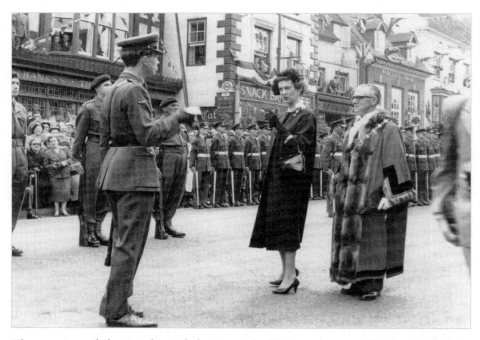

The granting of the Freedom of the Borough. The ceremony took place outside the Crown. The presentation was the highlight of a week of celebrations. Note Bees snack bar and café where many recruits stopped for refreshments.

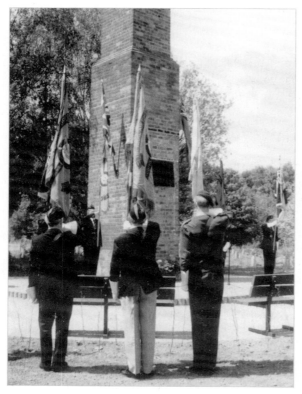

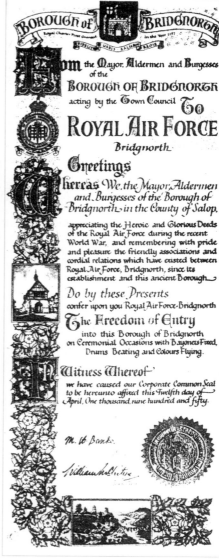

Above: *the memorial plaque unveiled on Saturday 24 May 1994. It was unveiled by Station Commander of RAF Cosford, Group Captain Mike Gilding, on behalf of all Allied Airman, WAAF, WRAF & RAF personnel who served at RAF Bridgnorth between 1939 and 1963. The plaque has been placed on what was the surviving No. 3 Wing cookhouse chimney.*

Right: *a scroll of the freedom of entry into the borough awarded on 12 April 1950.*

Below: *the Rose Marie Ballroom in Hollybush Road which was used to hold dances at the weekend.*

Appendix I

A List of Important Dates
in Bridgnorth's History

896: the Danes were driven from their settlements on the banks of the Thames. Their fleet having been destroyed they retreated Northwards and made their way to the forest of Morfe, adjacent to Quatford where they entrenched themselves in a strong fortification. There is evidence of a bridge over the Severn at Quatbridge as early as 896.

912–913: burhs built by Ethelfleda on Panpudding Hill.

1000: caves excavated at the Hermitage about this date.

1157: the borough incorporated by Royal Charter of Henry II.

1180: by this year Bridgnorth had increased in size and the town had extended outside the castle. St Leonard's church probably built about this date.

1205: a writ of King John in which he orders the keepers of his wines at Bristol to send six tuns of wine (about 1500 gallons) by water to Bridgnorth with the injunction that the wine was to travel night and day.

1212: gatehouse, or Barbican of Bridgnorth Castle, was erected. Official residence of the Constable of Castle.

1216: between 1216–1223 the town was surrounded by a turf rampart and ditch.

1225: earliest reference to Bridgnorth Kings Mill (now Fort Pendlestone) is 30 December.

1227: Henry III granted the borough its third and most important charter, by which the borough became a municipal authority separated from the rest of the Hundred of Stottesdon and independent of the sheriff. It was to have full powers over all trade within the town walls. Bridgnorth was to remain an independent municipal authority until 1974 when it merged with neighbouring authorities to form the Bridgnorth District Council and in 2009 to form the Shropshire Council.

1295: Edward I, again at Bridgnorth on 17 July. Ferdinand de Erdington and Andrew Bolding were the first members summoned to Parliament to represent Bridgnorth and they continued to do so until the Reform Act of the Distribution of Seats 1867, except during the Commonwealth, when only one was sent.

Thirteenth century: Whitburn Gate Built. Half moon battery in Pound Street built. Town walls built.

1303: the Grey Friars were in charge of the supply of spring water to the conduit at the High Cross in High Town and three other conduits.

1338: large flood caused considerable damage. Bridge needed repair. Flood caused by continuous rain from October until December.

1360: medieval Bridgnorth was an important route centre on the Bristol to Chester road and is one of only five towns mentioned on the River Severn in Gough's map of Britain.

1449: a water bailiff was employed to ensure free passage for traders on the river and towpath.

1478: William Botenor, commonly called William of Worcester, writing about bridges on the Severn stated that there was one of stone at Bridgnorth at this time.

1620: the spring water was put into lead pipes as a gift of Sir William Whitmore of Apley.

1636: the original Northgate was converted into a prison.

1644: Apley taken by Parliamentary forces.

1645: King Charles visited Bridgnorth three times.
 A Royalist officer named Symonds described St Leonard's as 'a noble structure ornamented with painted windows'.
 June 10: old town hall, through Northgate, ordered to be pulled down along with the New House as a military precaution.
 July 15: Oliver Cromwell's forces besieged the castle.
 September: High Cross demolished.

1646: final siege and capture of the castle by Parliamentary forces began.

1647: general collection for rebuilding St Leonard's church and town issued by the authority of Parliament under the Great Seal of England. None of this money appears to have reached St Leonard's.
 February: Colonel Baker in charge of demolishing Bridgnorth Castle.

1648: Parliament, by letters patent under the Great Seal, authorised the sending of briefs to all parts soliciting aid for the rebuilding of the church, almshouses, college and towns which were destroyed in the 'late warlike times'.

1657: Francis Moore (1657–1715), the astrologer and almanac maker, was a native of Bridgnorth. He went to London to practice physic and published his first almanac in 1699. It advertised some wonderful pills of his own invention but the almanac became more important than the pills.

1658: John Ray (or Wray), English historian, wrote 'I passed through Bridgnorth where I saw a fair street of new built houses and divers little houses cut out of the rock, particularly a large wine cellar which deserves to be seen'.

1666: Congregational chapel founded in 1666 with seating for 450 persons.

1672: it was ordered that Northgate be made fit and clean for prisoners and also repaired after it had received so much injury during the late wars.

1684: Bridgnorth was ordered to surrender its charters. This was because of the general opposition to The Corporation Act of 1661. The charters were saved because Charles II died early the following year.

1717: a water wheel installed to pump water up to a 6,500 gallon reservoir on the castle hill behind Governor's House. From there it was pumped to those who could afford to pay rent. Water wheels and pump was given by William Whitmore to the town. William Whitmore gave £5 'for a small plate to be run at the Races at Morfe'.

November 23: grant of Severn Waterworks, gift from William Whitmore to Bridgnorth Corporation.

1740: Northgate restored and rebuilt at the expense of the Corporation in place of the former structure which was very ancient.

1754: town maces made out of two staffs given as gifts by John Wolrych and Thomas Hincks (Town Clerk).

Some of the houses on the bridge demolished due to the arch east of them being rebuilt.

July 15: bridge repairs cost £222.00. Substantial damage occurred from floods.

1767, April 21: probably the last execution in Bridgnorth.

1781, October: first stagecoach service to use the Ironbridge. It was used to run a service from Shrewsbury to London via Broseley, Bridgnorth, Alcester and Stratford.

1788: first printing press established in Bridgnorth.

1796: tolls commenced on bridge.

1799: riverside towing path constructed.

1812–1813: upwards of 500 French officers, prisoners of war, were billeted in and around the town

1812: the last remains of the gatehouse on the bridge were removed.

1829: Congregational church on Stoneway Steps demolished and a much larger one built at a cost of £1,000 and opened on 25 October.

1833: first Wesleyan chapel was built down St Mary's Steps. Opened 4 July by Rev. W. Atherton.

1840: a report this year states barges and trows remained aground at Ironbridge during severe droughts.

1842: Baptist chapel in West Castle Street was built to seat 400 persons. Some of the old castle was destroyed during building as the chapel rests on its foundations.

1849: Bridgnorth had a cholera epidemic. 258 people died. Worst affected areas were Cartway, Friars Street and St Mary's Street.

1852: tolls taken off the bridge. There was a great flood of the River Severn.

1856: St John's Roman Catholic church at Northgate was erected.

1869, December: Great floods. Gas was disrupted for three nights due to severe floods. Candles and lamps were in short supply.

1873, February: St Leonard's tower officially opened costing £3,678. Local stone used but Alveley Stone used for windows. Architect was Mr Slater of Regent Street, London. Some stone from original tower is on show inside the church. Primitive Methodist chapel adapted from school building in 1873.

1890: first Axminster cloth produced at Southwell's Carpet Factory. It was seven by seven feet square. First design cloth completed on 22 October 1891. H&M Southwell formed into a limited company with a capital of £150,000. Serious collapse of a cave underneath Castle Walk.

1891: Bridgnorth Castle Hill Railway Company registered and was formed with a capital of £6,000.

November 2: work started on the Cliff Railway. Mr Law was the contractor for excavating the cutting.

December 16: doll show in the agricultural hall to get money for the new hospital to be built at Northgate.

1898: first telephone installed in the town.

1901: post office, Postern Gate, erected. When digging foundation for post office, three Romano-British coins dating between AD270 and AD300 were found and a small coin of Constantine the Great dated from about AD330. Some of the old castle wall was demolished.

1904: mayoress' chain acquired. Cobble stones from road surface were removed in High Street.

1912: Fort Pendlestone (then Town Mills) sold for £2,000 to Mr W.H. Foster of Apley, after being held by the town for eighty-six years. A landslide occurred on the east side of the castle hill. Grand Floral Carnival procession held in Bridgnorth to celebrate Empire Day.

1914: little St Mary's church in Low Town opened. Housed here was the table on which the castle surrender documents were signed.

1932: the Wesleyan chapel on St Mary's Steps was vacated and they moved to Cartway church. On 20 September a reunion of Methodist churches took place.

1937: Majestic Cinema opened by the Rt. Hon. Lady Acton on Monday 22 November.

1940: Bishop Percy's House became available and Major Foster decided to let the Boys Club move there. After the boys hard work he decided to present it to the club a few years later in 1945.

Bombs dropped on Bridgnorth and destroyed two cottages in Church Street, some in Pound Street and several other buildings in the town.

1945: Bishop Percy's House was presented to Boys Club by Major A.W. Foster M.C.

1951, August: no malt is made in Bridgnorth now S. E & A Ridley has just demolished the last of his malt-kilns. Of the thirty men he had employed in making malt, the last one had died a few months previous.

1955: K.S.L.I. granted freedom of entry into the town.

1958, January: Oldbury Wells School opened.
 Sept 14: The coat of arms of the borough of Bridgnorth granted, confirmed and allowed.

1959: Oldbury Wells Girls School opened.

1960: harbour master's house and other buildings demolished on the west side of the bridge.

1962: Methodists & Congregational united. They commenced worshipping together in Cartway Methodists' church.

1963, September: passenger trains ceased on the Severn Valley Railway.
 November: freight ceased.

1965, July 6: Severn Valley Railway Preservation Society formed.
 Fifty railway enthusiasts met at Kidderminster to discuss proposals to buy and operate the five and a half mile Bridgnorth-Hampton Loade section.

1966, February: offer of £25,000 was accepted to buy the railway line from British Rail.
 The Bridgnorth Journal inaugurated the 'Bridgnorth Walk'.

1973: St Mary Magdalene church restored. Bridgnorth District Council formed.

1976: St Leonard's church declared redundant & closed. Sep 29: final service at St Leonard's.
 Princess Anne opened Bridgnorth Leisure Centre.
 Footbridge from New Road to Severn Valley Railway removed.

1977: seven skeletons were found on the site of St John's House. Five of the skeletons were found together in what seemed to be a cemetery. The other two were found in the centre of the site. A fifteenth-century window tracery was also unearthed.

1978: St Mary's & St Leonard's churches join together and St Mary's becomes the new benifitue of the two churches.
 September 29, 30 and October 1: Bridgnorth twinned with Thiers, a small French town with similar style buildings to Bridgnorth.
 Bridgnorth & District Tourist Association formed.

1981, March 19: Phillip Rutter, Mayor, opened the museum after repairs.
 April 17: Clive Gwilt's first visitors' guide published.
 July 8: approximately three tonnes of timber removed from the base of a pier on the bridge by a JCB.
 June 1: Tatung take over Decca Pale Meadow Works. Cliff Railway carriages painted.

1983: carpet factory on riverside closed, ready to be demolished for housing.

1992: Bridgnorth twinned with Schrobenhausen, Germany, that had already twinned with Thiers a few years earlier.

1994: Britain in Bloom in the Heart of England, Bridgnorth was highly commended in the town category.

1995: Britain in Bloom in the Heart of England, Bridgnorth was highly commended in the town category.

1996: Britain in Bloom in the Heart of England, Bridgnorth was first in the town category.

1997: Britain in Bloom in the Heart of England, Bridgnorth was first in the town category.

1999: historic boards erected under the town hall arches to mark the millennium.

2000: Britain in Bloom in the Heart of England, Bridgnorth was winner of the Kenco town category.
 Bridgnorth was runner up in the Cemetery of the Year competition.

2001: Britain in Bloom in the Heart of England, Bridgnorth was winner of the Kenco town category.
 Bridgnorth was highly commended in the Cemetery of the Year competition.

2001: Britain in Bloom in the Heart of England. Bridgnorth was winner of the Judges' Trophy for Horticultural Excellence, for the Castle Gardens and Bridgnorth Cemetery.

2002: Britain in Bloom in the Heart of England, Bridgnorth was winner of the town category. Bridgnorth also received a gold award in the town category (R.H.S).

2003: Britain in Bloom in the Heart of England, Bridgnorth was first in the medium town category.
 Bridgnorth entered the *Entente Florale*, a European competition, and won a silver award plus an A.I.P.H. special award (one of only two individual prizes for community effort).
 Bridgnorth was granted Fairtrade Town status, the first town in Shropshire.

2005: unverified German papers dating from 1941 were found outlining new details about 'Operation Sealion', the military plans for an invasion from Germany. Bridgnorth was mentioned in the documentation.
 Britain in Bloom in the Heart of England, Bridgnorth won a gold award in the town category.

2006: Britain in Bloom in the Heart of England, Bridgnorth won a gold award in the town category

2007: Bridgnorth Independent Holiness Movement vacated their hall in St Leonard's Close.
 19 June: two weeks worth of rain fell on the Severn Valley in thirty minutes causing part of the Severn Valley Railway track to collapse at Highley. The railway remained closed for many months.

Britain in Bloom in the Heart of England, Bridgnorth won the gold award, best town in the region and was the overall winner.

2008: Britain in Bloom in the Heart of England, Bridgnorth received the Silver Gilt award in the town category.

2009, March 9: relief road at Northgate opened.

April: restored organ dedicated in St Mary's church. Bridgnorth Bylet Bowling Club re-opened after being burnt down. Six authorities join together to create Shropshire Council.

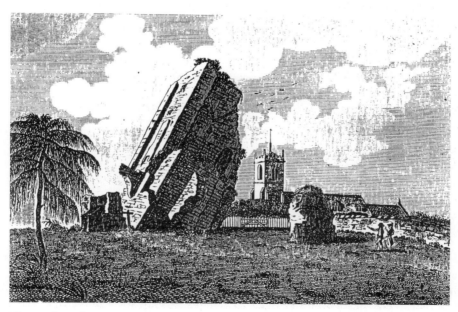

The castle and St Mary's church in 1794.

Appendix II
Local Heights Above Sea Level

Some interesting local heights above sea level from a 1941 Bridgnorth Almanac are listed in the table below.

	Feet		Feet
Fox Inn, Low Town	107	Oldbury Churchyard	290
Rodens Foundry	107	St Leonard's Church Tower	334
Centre of Bridge	118	Three Ashes Bank	350
S.V.R. Railway Station	150	High Rock	370
Quatford	165	St Leonard's Church, top of pinnacle	384
Castle Walk near cannon	211	Queen's Parlour	400
Panpudding Hill	212	The Wrekin	1,320
Castle Walk near railway's top station	220	Stipperstones	1,700
St Mary Magdalene's Churchyard	221	Titterstone Clee Hill	1,749
Town Hall	226	Brown Clee Hill	1,806
St Leonard's Churchyard	246	Mount Everest	29,002